CONTENTS

FOREWORD

Showcasing the talents of artists from Australia and Australasia, *Islands in the Sun* highlights the vitality and diversity of our region's indigenous art. Cairns Regional Gallery is proud to partner the National Gallery of Australia for this historic exhibition, the first major exploration of printmaking practice in Australasia.

Featuring the works of individual artists, *Islands in the Sun* also highlights the success of collaborative ventures between artists from differing cultural backgrounds. Cairns Regional Gallery boasts an extensive involvement with indigenous artists, not only through exhibitions, but also through workshops held at the Gallery. As I write this foreword, Torres Strait artist Robert Mast is conducting a printing workshop at Cairns Regional Gallery with over 300 local school children participating in the venture. Workshops are being held in conjunction with an Alick Tipoti linoprinting exhibition, *Lagaw Adthil: Island Legends*, which currently features in our Access Gallery.

We are also delighted to be a part of the touring itinerary for *Islands in the Sun*. The enhanced exploration and promotion of indigenous printmaking of our region means greater understanding, more audiences and ultimately assured careers for these talented artists.

Alice-Anne Boylan
Director, Cairns Regional Gallery
March 2001

ISLANDS
IN THE SUN

Prints by indigenous artists of Australia and the Australasian region

Roger Butler

Editor

■ national gallery of australia

Islands in the Sun
Prints by indigenous artists of Australia and the Australasian region

An exhibition organised by the National Gallery of Australia
in collaboration with Cairns Regional Gallery

Exhibition curators Roger Butler and Brian Robinson

Produced by the Publications Department of the National
Gallery of Australia, Canberra

Designer Kirsty Morrison
Editor Susan Hall
Printer National Capital Printing, Canberra

Cataloguing-in-Publication-data

Islands in the sun: prints by indigenous artists
of Australia and the Australasian region.

ISBN 0 642 54141 8.

1. Prints - 20th century - Australasia - Exhibitions.
2.Indigenous peoples - Art - Exhibitions.
3. Aborigines, Australian - Art - Exhibitions.
4. Prints, Australian - Aboriginal artists - Exhibitions.
I. Butler,Roger, 1948–. II. National Gallery of Australia. III. Title.

769.9

Distributed in Australia by:
Thames and Hudson
11 Central Boulevard Business Park, Port Melbourne,
Victoria 3207

Distributed in the United Kingdom by:
Thames and Hudson
30–34 Bloomsbury Street, London WC1B 3QP

Distributed in the United States of America by:
University of Washington Press
1326 Fifth Avenue, Ste. 555, Seattle, WA 98101-2604

Thanks to:
The artists, their dealers and those many people — teachers,
art advisers, printers, friends, professional colleagues —
and others who have provided help (and in some cases works)
for this exhibition and book. Our special thanks go to Anne
McDonald, Senior Assistant Curator, Australian Prints and
Drawings, National Gallery of Australia, who did so much
to bring this project to fruition. I would especially like to thank
Gordon Darling for his ongoing support. This publication is
supported by the Gordon Darling Australasian Print Fund.
www.australianprints.gov.au

Cover:
Banduk MARIKA *Banumbirr* (The Morning Star) 2000 from the
Yalangbara Suite linocut © Banduk Marika, 2000/licensed
by VISCOPY, Sydney 2001

This book is published in conjunction with the exhibition
*Islands in the Sun: Prints by indigenous artists of Australia
and the Australasian region.*

National Gallery of Australia
17 February – 27 May 2001

Islands in the Sun is a National Gallery of Australia
Travelling Exhibition, touring throughout Australia
and Aotearoa New Zealand in 2001–2002.

FOREWORD

Islands in the Sun is an important exhibition for the National Gallery of Australia. It brings together an extensive collection of prints by artists from Arnhem Land, Bathurst and Melville Islands, Torres Strait Islands, Papua New Guinea, Aotearoa New Zealand and the Pacific Islands. It crosses traditional geographic and cultural boundaries by including an innovative group of collaborative works.

It is this exploration of new areas that gives *Islands in the Sun* its remarkable strength and vitality. It shows how the arts have flourished amongst indigenous societies in the Australasian region since the 1960s and how the arts have been a potent force in maintaining cultural identity. It also makes clear that printmaking has proved vital in making the visual arts of these cultures widely accessible.

Islands in the Sun firmly positions Australia within its geographic region. By relating to the contemporary arts of the region it also recognises the National Gallery's role within the region both now and in the future.

Dr Brian Kennedy
Director, National Gallery of Australia
March 2001

INTRODUCTION

Redrawing the boundaries

Australian was once part of the greater continent of Gondwanaland, an ancient land which also included India, Antarctica, parts of Africa and the Americas. The landmass remained almost unchanged until about 160 million years ago when the various continents began to separate. Final separation of Australia is thought to have occurred about 95 million years ago. The regions that once made up Gondwanaland still have residual characteristics in common. Physically some of the oldest landmasses on earth, they host some of the most ancient species of fauna and flora. As these landmasses separated to form the regions we know today, the movement also caused the formation of the 'ring of fire', the volcanic belt which today encompasses Papua New Guinea, Aotearoa New Zealand and the Pacific Islands.

In the mid-1950s, the art historian Bernard Smith defined what should constitute the collection of a future Australian National Gallery, concentrating on the Pacific rim, the areas which once formed part of the ancient continent of Gondwanaland:

> Such a collection should not be confined to Australian art ... A great and unique art collection could be formed if centred upon the arts of South-East Asia and the Pacific basin. Such a collection would include, for example, the arts in India, Indonesia, the islands of the Pacific and both North and South America. European and Australian art would have their place but not dominate the field.

> Such a policy would have regard for the new gallery's likely purchasing strength; it would be grounded in Australia's immediate international interests; it would help us to form a closer acquaintance with and a better respect for the cultural activities of our neighbours; and, finally, it would not be a belated attempt to do something others have already done better than we can possibly hope to do.[1]

Two decades later James Mollison, then Acting Director of the Australian National Gallery, reaffirmed such ideas:

> we will concentrate, firstly, on the regions in which Australia is located; the Southern Hemisphere, the Pacific basin and South-East Asia.

However, despite its physical connection to the Australasian region, white Australia as a producer and consumer of art continued to look to Europe and, after the late 1940s, to the United States, as models. And when the National Gallery opened in 1982, it was widely seen as a repository of North American and European art.

When art from the Australasian region has been collected, it has usually been that of the 'great civilisations of the past', or 'primitive' or 'tribal art'. This is a problem that has been recognised in the past by only a few artists and cultural historians. Margaret Preston, in her article on 'The Orientation of Art in Post-War Pacific' (1944), postulated that our military, economic and cultural ties with Europe were at an end. She warned artists against the easy substitution of the culture of the United States and directed them to look at the Orient (including Papua New Guinea, the Pacific islands, Asia and India).

The art world has only recently recognised that these countries have contemporary cultures. The last few decades have seen changes in Australia's response to the region. Cultural exchanges between Aotearoa New Zealand and Australia now occur regularly — the most formal being ANZART (since 1981). The only regular art events which have a significant component of art from South-East Asia/Pacific are the Perth based *ARX (Artists Regional Exchange) Festival* (since 1987) and the Queensland Art Gallery's *Asia-Pacific Triennial of Contemporary Art* (since 1993). Australia has been represented in the *Indian Triennial* since the mid-1970s. Regional galleries have played

an important role in promoting art of the region, *Luk Luk Gen! Look Again!* (Perc Tucker Regional Gallery, 1990) and *Ilan Pasin* (Cairns Regional Gallery, 1999), being outstanding examples. The peoples of the Pacific Islands have also created their own festivals, the oldest being the *South Pacific Arts Festival* (biennial since 1972), which rotates between member countries and was held in Townsville in 1988.

Since the late 1980s the Visual Arts Crafts Board has devoted resources to cultural exchanges with South-East Asia, and residencies are now available in these countries. Asialink has placed exhibitions throughout the region and exchanges of artists, students and professional art staff are now commonplace.

Prints have played an important role, with exhibitions such as *The Western Pacific Print Biennale* bringing together work by many of the artists of the region.

Islands in the Sun

The indigenous peoples of the Australasian region share the same recent history although they belong to different cultures. All have been colonised by Europeans and all have had to struggle to maintain their cultural identity.

The generation of indigenous artists, writers and politicians that matured in the 1960s intensified their campaigns to reclaim their lands and cultures. Western Samoa became independent in 1962; Australian Aboriginal people gained citizenship in 1967; Nauru was proclaimed independent in 1968; Tonga and Fiji in 1970; Papua New Guinea in 1975; the Solomon Islands and Tuvalu in 1978; Kiribati in 1979. The Cook Islands became internally self-governing in Free Association with New Zealand in 1965, as did Niue.

In 1987 the legal status of the Treaty of Waitangi, signed in Aotearoa New Zealand in 1840 between Maoris and Pakeha, was upheld and in Australia in 1992 the Mabo case decided that native title should be based on the traditional connection to, or occupation of, the land.

During these decades some placenames have reverted to pre-European settlement usage: Ayers Rock is once more Uluru, New Zealand is again referred to as Aotearoa, the people of Papua New Guinea call their land Niugini and the Gilbert Islands are again Kiribati.

The arts flourish in these societies and there has been a renewed interest in traditional images, designs and narratives. New images and stories have also evolved, reflecting the changing times and the introduction of new technologies.

Printmaking has proved vital in making the visual arts of these cultures widely accessible. This exhibition and catalogue includes linocuts and woodcuts, screenprints and lithographs by the indigenous peoples of Arnhem Land, Bathurst and Melville Islands, Torres Strait Islands, Papua New Guinea, Aotearoa New Zealand, New Caledonia, Niue and Samoa. Also included is a group of works which cross traditional geographic and cultural boundaries — for instance, Aboriginal artists producing collaborative prints with artists from Indonesia and the Philippines.

Islands in the Sun: Prints by indigenous artists of Australia and the Australasian region is not only a response to Australia's position in the Australasian region, but also a testament to the art of printmaking as a bringing-together and affirmation of indigenous culture.

Roger Butler

1 *Canberra Times,* 8 October 1955

PRINTMAKING BY ABORIGINAL ARTISTS

The early 1970s were optimistic years for Australians, both indigenous and white. Within the first weeks of taking office in December 1972, the Labor Government established a Department of Aboriginal Affairs, set up an inquiry to ascertain how Aboriginal land should be returned to its people, withdrew Australian forces from Vietnam, endorsed the principle of equal pay for women and increased funding for the arts.

The arts themselves were undergoing radical changes. Painting, particularly 'hard edge' colour abstraction, was rejected by many as 'bank art' — decoration for a consumer society. Unsaleable, ephemeral or democratic art forms were taken up. Earthwork sculpture, ritual-like performance art, community-based cooperative projects, video, photography and printmaking became the most vital areas of activity. Printmaking facilities were established in schools and commercial print workshops opened. Screenprinting was particularly popular, due to the inexpensive equipment needed and the ability to produce multi-colour prints. The cheapness and 'contemporary look' of screenprints also led to their adoption by political artists.

Australian Aboriginal people have no tradition in printmaking practices, other than the stencilled images (usually of hands) that are to be found on cave walls throughout Australia. However, many Aboriginal artists have found printmaking a natural extension to their painting and sculpture.

The engraving of wood and linoblocks is a similar process to the incising of designs in stone or boab nuts or shells, or the carving of wooden sculpture and utilitarian objects. The sequential overprinting of colours in screenprinting is paralleled in the way traditional bark paintings are realised, and the same chalky opaque colours can be obtained.

It was within this context, with the desire both to preserve and promote their visual culture and achieve financial independence, that Aboriginal

people began experimenting with printmaking in 1967. The first prints were produced by the artist, writer and activist Kevin Gilbert, who played a central role in establishing the Tent Embassy outside Parliament House in Canberra in 1972. The linocuts he produced in Long Bay gaol did not become widely known until a decade later. They can now be seen as a forerunner of his poetry, plays, photographs and political texts.

There are also a number of other isolated examples of early prints being produced, the techniques being demonstrated by school teachers, craft advisers, or white artists. At Nguiu, Bathurst Island, Bede Tungutalum learned the rudiments of woodblock cutting and printing from Madeline Clear, the local art teacher in about 1969. Although a few single images were produced at the time, the emphasis was on textile printing. By 1970 Tungutalum, together with Giovanni Tipungwuti, had established Tiwi Designs which, due to the success of their block and later screenprinted fabrics, acted as a model for other communities.[1]

A year later, in 1971, John Rudder, who worked at the local Mission on Galiwinku (Elcho Island), provided artists Wilson Manydjirri, Charlie Matjuwi and Botu with linoblocks, on which they engraved designs that traditionally would have been cut to decorate wooden pipes. The blocks were not printed until the 1980s and printmaking did not develop in the community.[2]

In 1976, while visiting Arnhem Land, Jörg Schmeisser (Head of Printmaking Department, Canberra School of Art 1978–1997) traded information with an Aboriginal of the area named Albert. Schmeisser demonstrated how prints were produced, and Albert demonstrated the preparation of bark for painting. This exchange resulted in Albert's production of a small drypoint. In 1978 Schmeisser worked with Narritjin Maymuru and his sons while they were artists-in-residence at the Australian National University.[3]

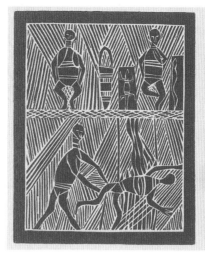

(left) Charlie MATJUWI *Djirkitj* 1971 Elcho Island, Northern Territory, printed Canberra c.1985 linocut, printed in red-brown ink from one block on thick handmade paper 12.6 x 10.1cm printed by Theo Tremblay at the Canberra School of Art Gift of Theo Tremblay 1987
(right) Wilson MANYDJIRRI *Untitled* 1971 Elcho Island, Northern Territory, printed Canberra c.1985 linocut, printed in red-brown ink from one block on thick handmade paper 12.6 x 10.1cm (each printed image) printed by Theo Tremblay at the Canberra School of Art Gift if Theo Tremblay 1987

This was the beginning of The Canberra School of Arts' (and later Theo Tremblay's and Studio One's) involvement with the teaching of printmaking techniques to Aboriginal and Torres Strait Islander artists. In the late 1960s printmaking had been introduced by Ulli and Georgina Beier to both Nigeria and New Guinea in this same manner.[4]

The publication of Aboriginal prints was fostered by commissions given to already successful painters. In 1978 Dinny Nolan Tjampitjinpa, a leading member of the Anmajera tribe, was commissioned by the Canadian Government to produce a print for the *Commonwealth Print Portfolio*. The portfolio also included a print by Kenojuah, an Inuit (Canadian Eskimo) artist.[5] Like the Aboriginal Australians, the Inuit people had no tradition of printmaking, but from 1958, when relief-printing techniques were introduced, the Inuit have reaffirmed their artistic heritage of stories and images. A strong market for Inuit art has developed, enabling many of the artists to achieve financial independence. Inuit prints have been distributed through the Canadian Eskimo Arts Committee, later Arts Council, since 1961.[6] Exhibitions of Inuit prints were shown in both Australia from 1963 and Papua New Guinea in the early 1970s. Artists such as Bede Tungutalum drew ideas and inspiration from exposure to work by other indigenous artists:

In 1978 I was the art representative for the Commonwealth Games at Edmonton in Canada. We were there for a while. I looked at Indian art to see how they did prints on stones; they had quite a different way of doing it from us. That's where I got many of my first ideas from — from the Indians [Inuit]. In Vancouver they make very nice designs, and very good carvings as well. I actually visited some Indian Reservations and saw the people make their own carvings. Then in 1983 I went to Papua New Guinea for the South Pacific Arts Festival. Papua New Guinea is a nice place. People there have their own culture — a very strong, very strong culture. I really like their carving. I got some ideas from them. I wouldn't mind going back there to study more.[7]

The success of such a model influenced the Aboriginal Artists Agency (established in 1976), to produce a set of six screenprints by artists from the Western Desert. David Rankin, director of the print publishers Port Jackson Press and Anthony Wallis, manager of the Agency, initiated the project. The two artists selected for the 1979 project were Johnny Bulun Bulun and David Milaybuma, both from the Maningrida area of west Arnhem Land.

These were the first prints produced by Aboriginal artists to be marketed widely, being offered to 22,000 American Express cardholders. But despite this wide publicity, only 54 prints were sold. Prints were then distributed through regular Port Jackson Press outlets and later the Aboriginal Artists Agency.

The *Second Biennial Conference of the Institute of Aboriginal Studies* (1982), held at the National Gallery of Australia, discussed Aboriginal printmaking and offered support to artists such as Banduk Marika, who first exhibited her linocuts at the *Women's Festival*, Seasons Gallery, in Sydney in the same year. Women's venues were important, the first exhibition of prints from the Indulkana Community being held at the Women's Art Movement Gallery, Adelaide in 1983.

Until the 1990s, most prints made by Aboriginal artists were produced in southern cities, far from the northern community population centres. Many of the projects carried out by these workshops were facilitated by government funding organisations. The early prints of Kevin Gilbert and Jimmy Pike had been made in Sydney and Fremantle prison workshops respectively. The lithograph by Dinny Nolan Tjampitjinpa for the 1978 Commonwealth Games had been printed at the Victorian College of the Arts in Melbourne. The 1979 screenprints by Johnny Bulun Bulun and David Milaybuma were drawn and printed in the Melbourne studio of Larry Rawlings; many prints were produced at the Canberra School of Art Printmaking Workshop (from 1976), Studio One in Canberra (from 1989) and the Australian Printmaking Workshop in Melbourne (formerly the Victorian Print Workshop) from 1988.

Some of these ventures were commercial operations, and the nature of the printmaking process and the final 'look' were often pre-determined. The artists were often only shown a single technique and had little opportunity to develop their knowledge of printmaking or to learn other ways of making art. To produce these works, the artist invariably travelled to the southern centres.

There were also forays to Aboriginal communities by artists and printers such as Theo Tremblay who, from 1989, has taken his small lithographic press to the Tiwi Islands, Central Arnhem Land and South Australia; Helen Eager, who in 1990 initiated the Utopia Suite of Woodcuts; and Martin King, who has regularly taken a small etching press into the Kimberley Ranges, thus enabling local artists to participate more fully in the making and printing process.

The *Getting into Prints* symposium, held at the School of Fine Arts, Northern Territory University in April 1993, was a watershed for Aboriginal printmaking in Northern Australia. It led directly to the opening up of the facilities of the University to Aboriginal communities, with Leon Stainer as the major facilitator. Eventually this led to the establishment of Northern Editions with Basil Hall (formerly of Studio One) as Director. Red Hand Prints, established in 1997 by Franck Gohier and Shaun Poustie, also operated in Darwin until 2001. In Western Australia in 1998 the Edith Cowan University established the Open Bite Access Workshop, which is being utilised by local Aboriginal artists.

A second conference, *More than One: Central Australian Printmaking Workshop*, held in Alice Springs in 1995, provided a more hands-on approach for Aboriginal artists.[8] Today many communities have access to printmaking equipment. Among those that have facilities for screenprinting, etching or linocuts are Tiwi on Bathurst Island and Munupi Arts at Pularumpi on Melville Island (since 1989), and Iwantja Arts and Crafts, Indulkana (since 1981). More recently, workshops have been established at Yirrkala and Oenpelli while others are planned for Warmun (Turkey Creek) and Kalumburru. Neville Field introduced printmaking at Wilu Arts with the Kulpitarra Community at Alice Springs in 1993 and the Lockhart River Aboriginal Community has produced prints since late 1996, supported by Geoff Barker. Many other communities, while not producing limited edition prints, have facilities for fabric and T-shirt printing.

With the opening up of such print workshops, Aboriginal artists from the Top End now have the option of exploring the many forms of printmaking in a relaxed atmosphere and at their leisure. Screen and wood and linoblock printing remain the most popular techniques used in these communities. The equipment needed is low in cost, easy to maintain and the processes are simple to teach. Etching is practised in some communities but lithography, due to technical

difficulties, hardly ever. Collograph printing, introduced recently, is also proving popular.

The exhibition *Old Tracks New Land: Contemporary Prints from Aboriginal Australia* (1992–3), organised by the Aboriginal Arts Management Association in conjunction with the Massachusetts College of Art in Boston, resulted in unprecedented sales and has led to a dramatic increase in the number of artists experimenting in the medium. The promotion of Aboriginal prints, both in Australia and overseas, is now facilitated by the Australian Art Print Network which was established in Sydney in 1996.

In 1986 the Print Council of Australia devoted an issue of its magazine *Imprint* to printmaking by Aboriginal artists.[9] It predicted that the number of urban based Aboriginal artists producing prints would increase, but this has not eventuated. Many prominent print artists today, such as Arone Raymond Meeks and Ellen José, were already working in the 1980s. Some artists have turned to other media. Fiona Foley, for instance, is now making photographs and Judy Watson, Karen Casey and Ian Abdulla have concentrated on painting. Of more recent practitioners Treahna Hamm's detailed decorative prints have been awarded major prizes, while Gordon Bennett's postcolonial adaptations have created new directions for Aboriginal art.

On the other hand, printmaking by Aboriginal artists in communities has developed into one of the most viable and significant art forms.

A significant area of expansion in recent years has been the production of prints by Torres Strait Islanders. Activity has centred on the Printmaking Department at the Aboriginal and Torres Strait Islander Arts Centre in Cairns, established by Anna Eglitis in 1984. The expectation of the initial students was to produce screenprinted fabrics for sarongs and T-shirts for the local tourist market.[10] It has become the major centre for Aboriginal, and in particular Torres Strait Islander, art. Graduates Dennis Nona, Zane Saunders and Alick Tipoti have later worked at the Canberra School of Art.

The distinctive linocuts produced by the Torres Strait Islanders, with their intricate cutting and narratives, often show cultural connections to Papua New Guinea.

The connection between Aboriginal and Torres Strait Islanders with other indigenous peoples producing prints in the Asia-Pacific and Pacific rim region is long standing. Bede Tungutalum visited Canada in 1978 as did Bevan Hayward Pooaraar in 1991. The second *Western Pacific Print Biennale*, organised by the Print Council of Australia in 1978, exhibited prints by Aboriginal artists alongside works by Indonesian, Thai and other near-neighbouring countries. In 1984, works by Jimmy Pike and other Aboriginal artists were included in the Indian Ocean Arts Festival. Collaborations with Aotearoa New Zealand are also expanding. Muka Studio, Auckland (established 1984, muka is the Maori word for flax) produced lithographs for Maori artists as well as Aboriginal artists such as Paddy Fordham Wainburranga (1991). Marian Maguire, in Christchurch (The Limeworks and PaperGraphica) has also been active in printing lithographs for Maori, Pacific Islanders and Pakeha artists. The Torres Strait Islander artist Brian Robinson has worked as artist-in-residence in the Solomon Islands (1996) and in Noumea, New Caledonia (1996). Michel Tuffery, an Aotearoa New Zealand artist of Samoan Tahitian descent, has participated in printmaking workshops throughout the region, including the Cook Islands, the Solomon Islands and New Caledonia and was artist-in-residence at the Aboriginal and Torres Strait Islander Art Centre, Cairns (1996).[11]

Aboriginal contact with the people of South-East Asia has existed for some centuries. Indonesian boats (especially from Macassar) travelled to the Arnhem Land coast to collect and process trepang (sea slug, sea cucumber), turtle shell and wood. Evidence of these enterprises is found in images, words and rituals of Aboriginal Australians of the region.[12]

The contemporary interaction of Aboriginal and Indonesian artists dates back to 1975 when three Ernabella artists travelled to Yogyakarta, Indonesia, to further study batik techniques.

Artists from Ernabella Arts revisited Indonesia in 1992 and 1997.[13] In 1999 Utopia artists held a batik workshop in Alice Springs, with artists from Brahma Tirta Sari Workshop, which resulted in a number of collaborative fabrics. Works from this project were exhibited in *Beyond the Future; The Third Asia-Pacific Triennial of Contemporary Art* in 1999.[14]

The *Asia-Pacific Triennial*, organised by the Queensland Art Gallery (since 1993), has acted as a catalyst for more Aboriginal and Asian collaborations. The *Australasian Print Project — The Meeting of Waters*, organised by the Printmaking Workshop at the Northern Territory University in 1997 resulted in a large screenprint and a five panel etching, with artists from Indonesia, the Philippines, Arnhem Land and Darwin all participating to produce the images.

Compared to the large number of Aboriginal artists producing paintings on bark, canvas or paper, there are relatively few who have so far worked as printmakers. However, the very nature of printmaking — its ability to replicate an image — has enabled Aboriginal practitioners to reach a wide audience. Prints, whether using traditional or urban images, are a means of contributing to the increasing self-determination of Aboriginal Australians.

Roger Butler

1 See Adrian Newstead, 'Tiwi Aboriginal Designs' in *Craft Australia*, Spring 1983, pp.92–95; *Tiwi Designs*, Sydney: Hogarth Galleries, 1982.
2 Information from Theo Tremblay who also printed the blocks.
3 Information from Jörg Schmeisser, who printed the plates.
4 Jean Kennedy, 'Printmaking in New Guinea' in *Artists Proof*, vol.11, 1971, pp.88–90, for 'Printmaking in Nigeria', see ibid., pp.102–105, vol. 7, 1967. It might also be noted that the best known American Indian artist Fritz Scholder began making prints in 1970. See Clinton Adams, *Fritz Scholder, Lithographs*, Boston: New York Graphic Society, 1975, p.19.
5 Discussions with Anthony Wallis and Bea Maddock, August 2000. See also brochure accompaying *Commonwealth Print Portfolio*. This was supplied to me by Anthony Wallis.
6 See Ernst Roch (ed), *Arts of the Eskimo: Prints*, Montreal: Signum Press, 1974, pp.11–16.
7 *Aboriginal Voices: Contemporary Aboriginal artists, writers and performers*, compiled by Liz Thompson, Sydney: Simon and Schuster, 1990, p.72.
8 *More than One: Central Australian Printmaking Workshop* video, Alice Springs: 15–17 September 1995. [Darwin]: Department of Education, Aboriginal Development Unit, 1996. 6 videocassettes.
9 'Prints by Australian Aborigines', *Imprint* vol.21, no.3–4, Oct. 1986.
10 Anna Eglitis, 'Artistic Technique Training at Cairns TAFE' in *Marketing Aboriginal art in the 1990s*, Canberra: Aboriginal Studies Press, 1990, pp.83–87.
11 Christine Delany, 'Creativity in the Forest' in *Artlink*. Vol.16, no.4, pp.34–36.
12 See D.J. Mulvaney, *Encounters in Place*, St Lucia, Queensland: University of Queensland Press, 1989, pp.22–28.
13 James Bennett, 'Ernabella Batik' in Louise Partos (ed.) *Warka Irititja Munu Kuwari Kutu: Works from the past and the present*, Ernabella, South Australia: Ernabella Arts Incorporated, 1998, pp.31–36.
14 Jim Supangkat, 'Brahma Tirta Sari Studio and Utopia Batik' in *Beyond the Future: The Third Asia-Pacific Triennial of Contemporary Art*, Brisbane: Queensland Art Gallery, 1999, pp.194,195.

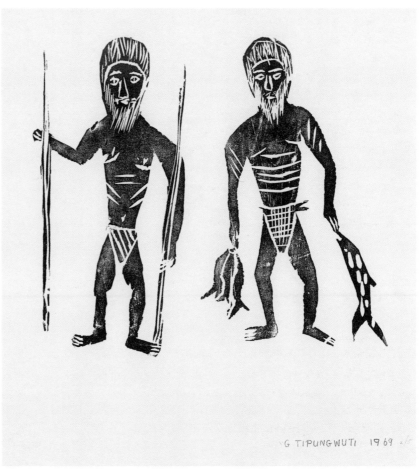

Giovanni TIPUNGWUTI
Two fishermen 1969 woodcut

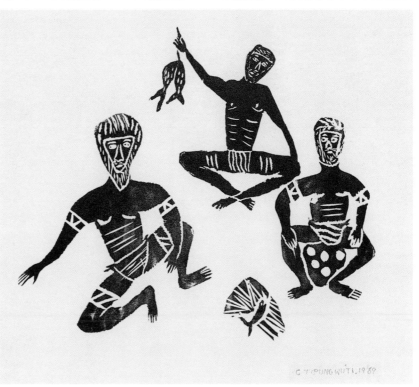

Giovanni TIPUNGWUTI
Three men cooking fish 1969 woodcut

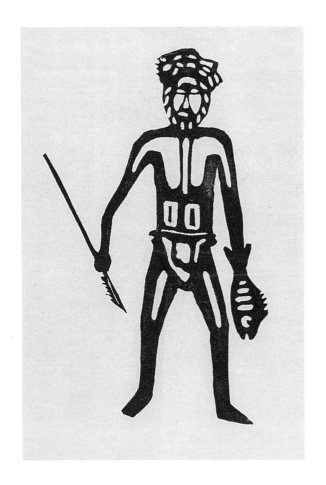

Bede TUNGUTALUM
Man with spear and fish c.1969 woodcut

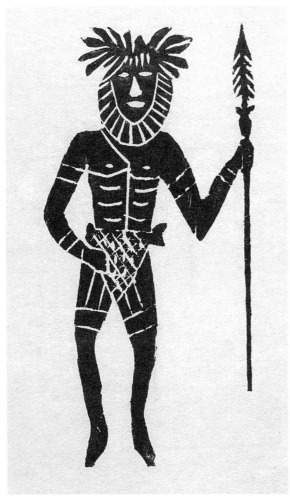

Bede TUNGUTALUM
Man with spear c.1969 woodcut

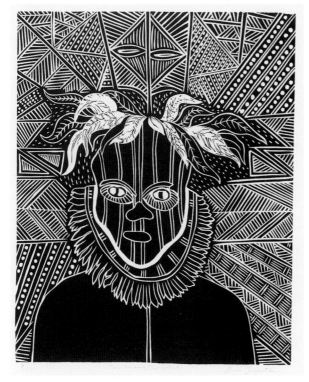

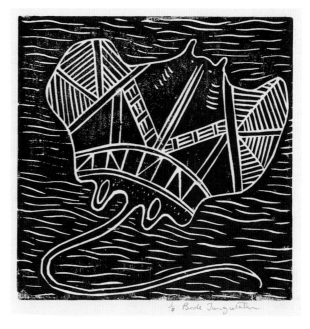

Bede TUNGUTALUM
Owl dreaming (Self portrait) 1988 linocut

Bede TUNGUTALUM
Stingray c.1970 woodcut

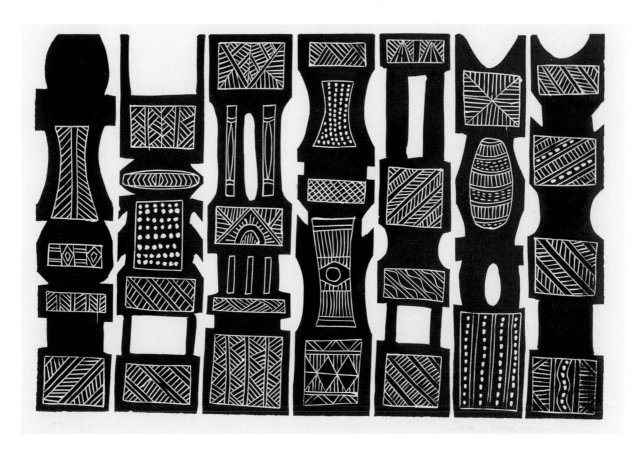

Bede TUNGUTALUM
Pukumani poles 1 1988 linocut

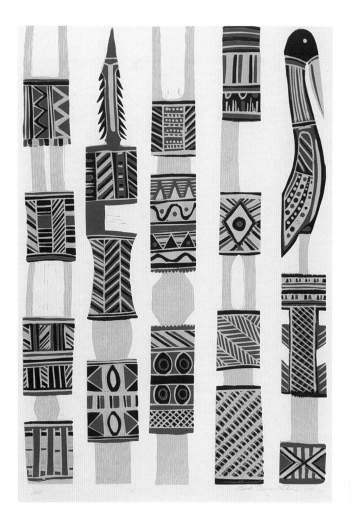

Bede TUNGUTALUM
Pukumani poles 1988 linocut, printed in colour

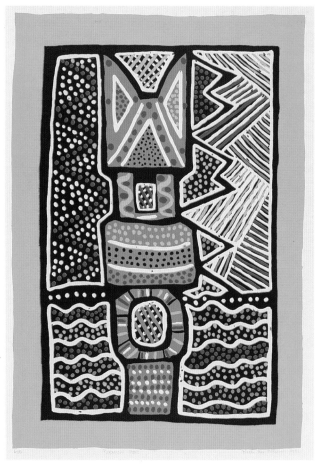

Thecla Bernadette PURUNTATAMERI
Pukumani poles 1991 screenprint

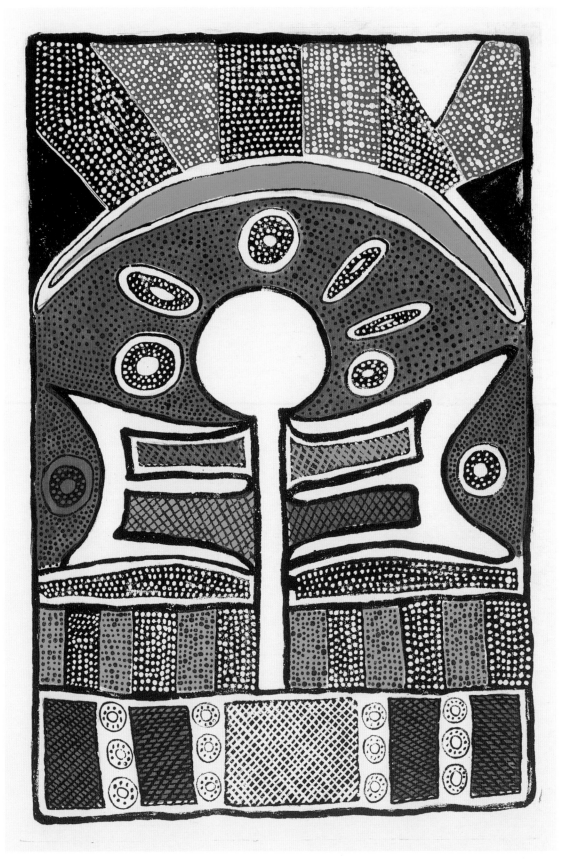

Janice MURRAY
Flying fox and bamboo at Muranapi 2000
etching and lift ground etching, printed in three colours

Tiwi artists Pedro Wonaeamirri, Maryanne Mungatopi and Janice Murray collaborated with the Australian Print Workshop in a project which involved visiting the South Australian Museum in Adelaide and spending three days viewing the Mountford Collection, which includes a major

holding of Tiwi cultural material. Before this project, one of the only ways that the Tiwi artists were able to reference this traditional Tiwi imagery was from photographic reproductions in an old photocopy of Charles Mountford's book *The Tiwi: Their art, myth and ceremony* (1958). Following a period of extensive research, drawing and documentation, the artists spent eight days at the Australian Print Workshop working with the printers to make a series of large-scale etchings based on the objects they had seen in the Mountford Collection.

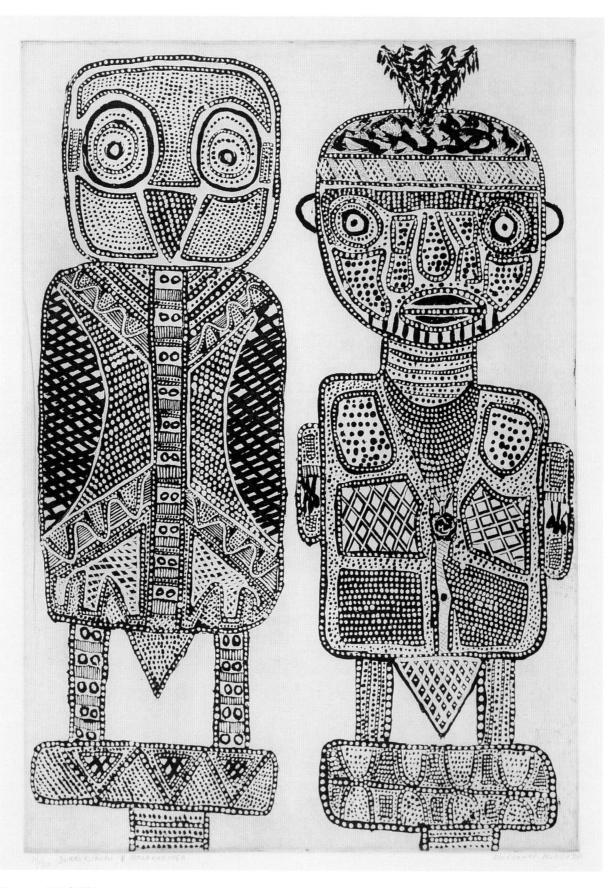

Maryanne MUNGATOPI
Jurrukukuni and Malakaninga 1998 lift ground aquatint, printed in two colours

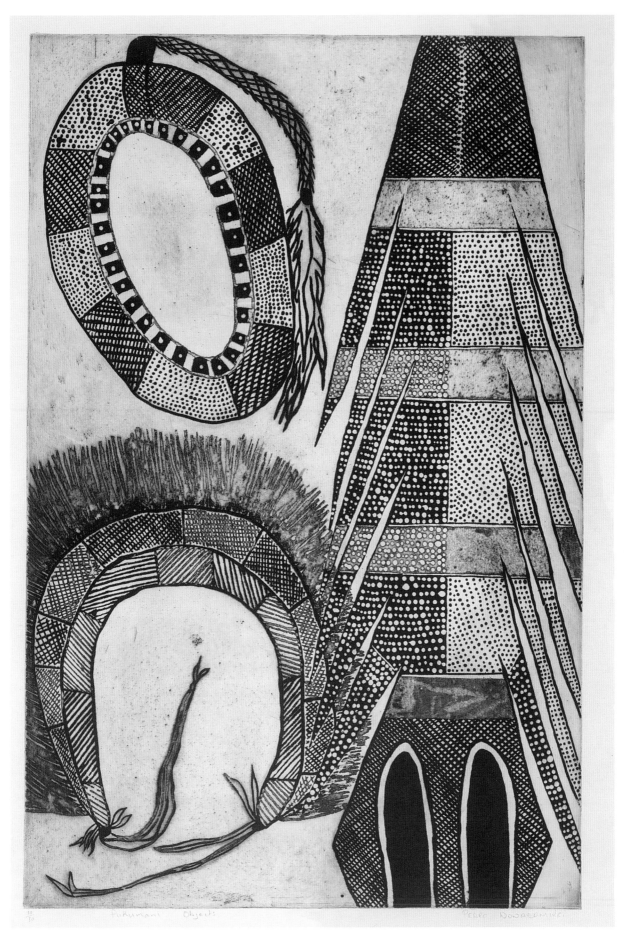

Pedro WONAEAMIRRI
Pukamani objects 2000 etching

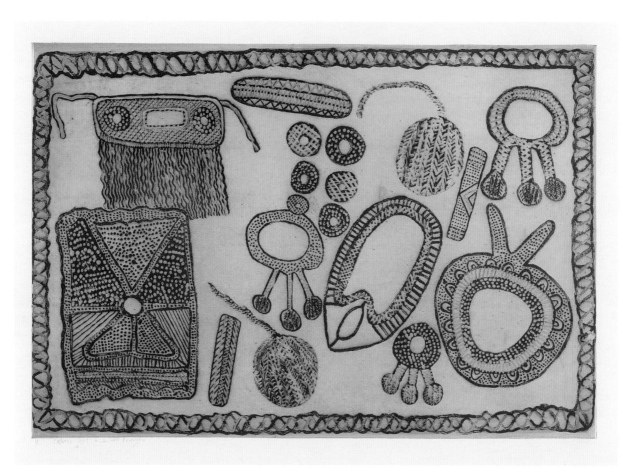

Maryanne MUNGATOPI
Objects used Kulama Ceremony 2000
etching and lift ground aquatint printed in two colours

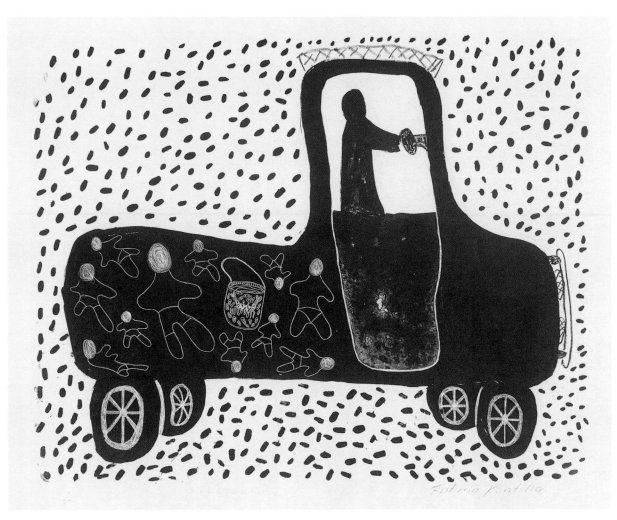

Fatima KANTILLA
This mob going hunting 1991 lithograph

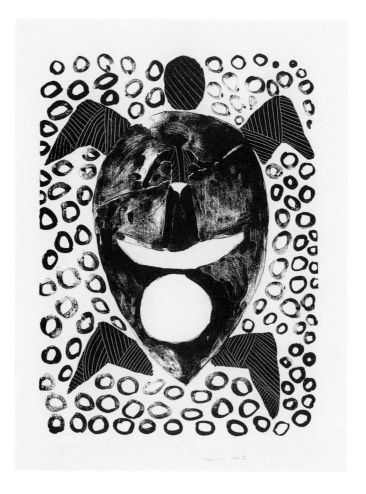

Reppie ORSTO
Jarrikarlami (Turtle) 1991 lithograph

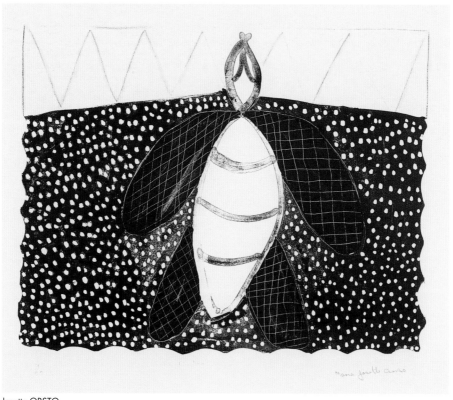

Josette ORSTO
March fly dreaming 1991 lithograph

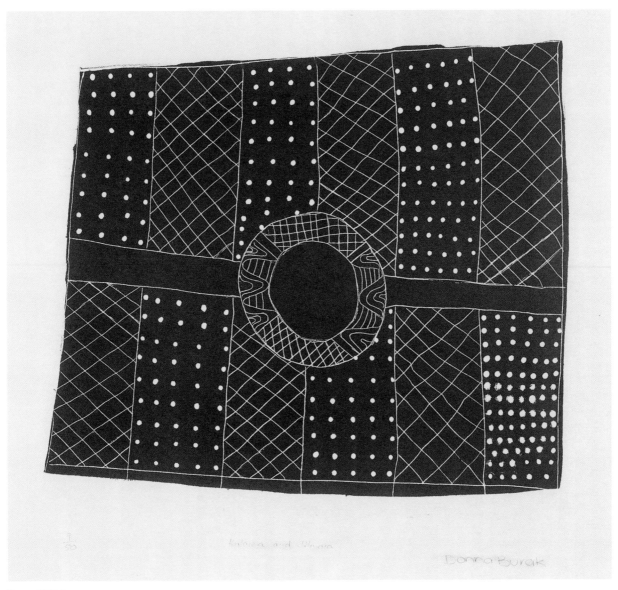

Donna BURAK
Kalama and Jilmara 1991 lithograph

Jean Baptiste APUATIMI
Kulama 1999 hard ground etching, printed in two colours

Jean Baptiste APUATIMI
Parlini Jilamara 1999 hard ground etching, printed in two colours

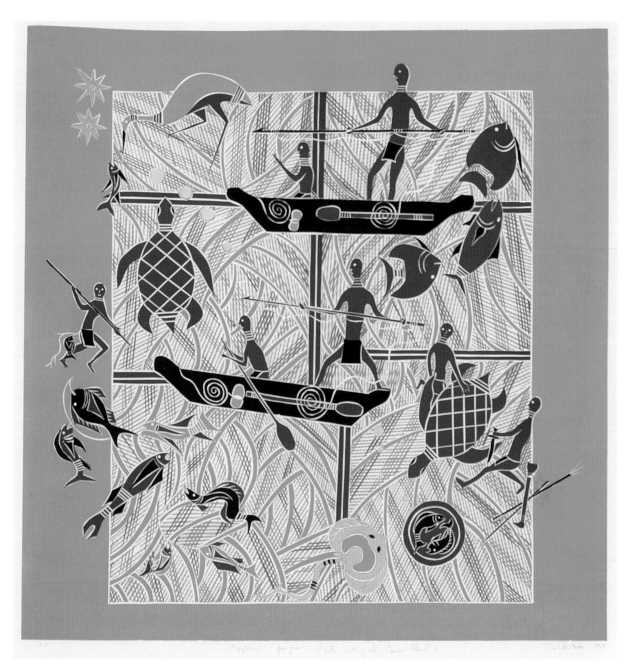

Banduk MARIKA
Miyapunawu Narrunan — Turtle hunting Bremer Island
1989 linocut, printed in colour

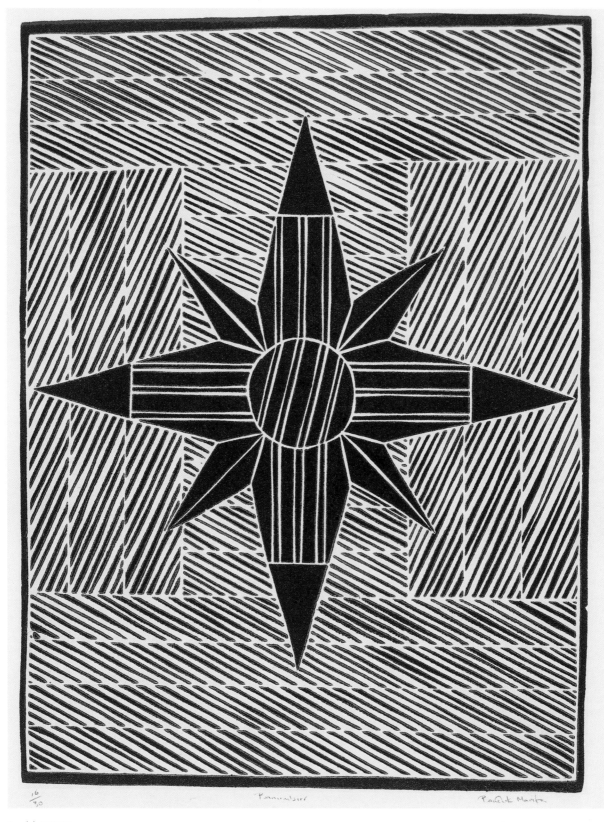

Banduk MARIKA
Yalangbara Suite
2000 linocuts

The six prints in the *Yalangbara Suite*
explore the theme of Guyurr (the Journey)
of the Ancestor creators Djan'kawu to the
shores of north-east Arnhem Land.
The Djan'kawu, two sisters and their brother,
came from the east by canoe to Arnhem Land
and then travelled west creating names,
animals, landforms and languages and giving
birth to the Dhuwa moiety clans of the area.

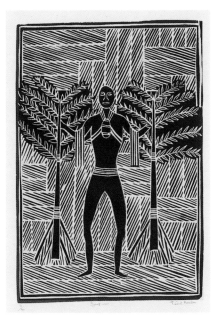

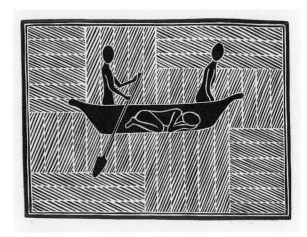

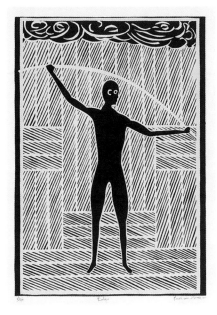

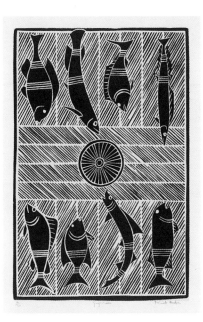

The suite of six prints depicts the stages in the
siblings' journey from the island of Burralku
to the shores of the mainland:
1. *Banumbirr* (The Morning Star)
2. *Djan'kawu* (The Djan'kawu standing at his home,
 Burralku)
3. *Guwulurru* (The canoe in which the Djan'kawu
 set out on their journey)
4. *Bol'ngu* (The Thunderman — bringer of storms
 during their journey)
5. *Guyamala* (The naming of the fishes)
6. *Milngurr* (The sacred waterhole)

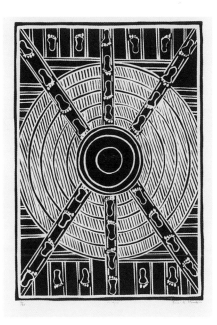

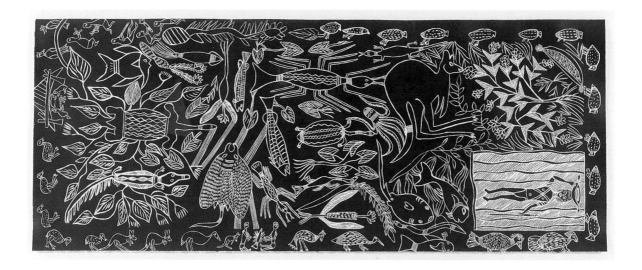

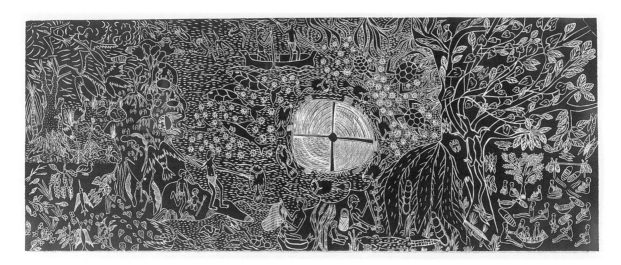

Marrnyula 2 MUNUNGGURR
Mundul MUNUNGGURR
Boliny WANAMBI
Gundimulk WANAMBI
Dhuwarrwarr MARIKA
Naminapu MAYMURU-WHITE
Djolu YUNUPINGU
Nancy GAYMALA 1 YUNUPINGU
Nyapanyapa YUNUPINGU
Barrupu YUNUPINGU
Djapirri MUNUNGIRITJ
Mananu WUNUNGMURRA
Maringgurrk MARAWILI
Birrala YUNUPINGU
Patrick WHITE

Yirritja Ga Dhuwa Ngatha 1999 linocuts

These two prints are a collaborative work by the *Yolngu Miyalk* (Aboriginal women) of Yirrkala; the title means 'the food of the Yirritja and Dhuwa people'. It is about the interplay between people, ancestors, seasons and hunting cycles in north-east Arnhem Land. Although distinctly different, the panels mirror each other in theme and sub-themes, which include ancestral beings, *mokuy* or spirit people, season cycles, ceremonial practice and common knowledge amongst the Aboriginal communities in north-east Arnhem Land about local resources.

MOTIF ETCHING: THE HISTORY OF ILAN[1] PRINTMAKING

Over the past couple of years there has been an influx of prints, especially linocuts, being produced by Torres Strait Islander artists. These skilfully refined prints, intricately detailed with traditional motifs, are an extension of an ancient art form used to ornament functional items and ceremonial objects. This form of low relief carving was lying in a dormant state until just recently, when a younger group of contemporary Island artists started utilising the traditional skills and techniques of their forefathers, in conjunction with modern materials, in an effort to revitalise a once vibrant culture and to tell the stories of their ancestors. This surge in art production has been helped along by the establishment and assistance of art centres in remote communities and by courses specifically designed for indigenous people at Technical and Further Education Colleges (TAFEs) and universities Australia wide. Such courses, although allowing students to experiment freely with design and materials, produce graduates who conform to the western concept of art and artist.[2] They produce work that blends together tradition, modern society and conflict, a statement of cultural affirmation and identity unlike that of their Island-based colleagues (traditional community artists) who produce work according to established cultural rules.[3]

A tropical location

The Torres Strait Islands lie off the far north-eastern tip of Australia, in the shallow seas of the Torres Strait which links the Arafura Sea to the west and the Coral Sea to the east. Sandwiched between Cape York Peninsula and the south-west coast of Papua New Guinea, the Strait measures 150 kilometres at its widest point. Comprised of islets and partially exposed sandbanks and coral cays, there are within the Strait more than 100 islands, of which only 16 are currently inhabited. As well, there are two Islander communities, Bamaga and Seisia, on the mainland of Australia at the tip of Cape York Peninsula. Torres Strait is divided up into four regions: Eastern, Central,

Western and Top Western, according to geological features and location. Within these regions, language varies, as do customs and art styles. This is closely connected with religious practice and cult rites. Shrouded in mystery and superstition, these islands lay virtually untouched by the outside world until 1606 when discovered by Spanish explorer Luis Vaes de Torres.[4]

Cultural practice throughout the Strait has long had close affiliations with that of Papua New Guinea, which is evident in the extensive trading of ritual artefacts between both groups. Artistic practice played an important role in everyday life, as this gave shape to the Islanders' gods. The spirit world was given form through the creation of ritual objects, in particular ceremonial masks used in dance. The mask was the medium by which Islanders could evoke spiritual protection during war, hunting, initiation and cultural practice, and ceremonies.

In the latter half of the 19th century, the advent of the London Missionary Society (LMS) and the introduction of Christianity and government services to the Islands disrupted, but did not fully eradicate, cultural practices and lifestyle.[5] The Torres Strait people were forced to quickly adapt to their new environment and as a consequence created a new lifestyle, one that was interconnected with their Pacific neighbours, Christianity and an increasing government presence. With the outside world bringing new attitudes and new technologies, traditional materials such as turtleshell and pearlshell were replaced by their modern counterparts: processed woods and timbers, metals and plastics.

Traditional artefacts and markings

The process of etching, incising and mark making by Torres Strait Islander artisans began as far back as 25,000 years ago, possibly even longer, as life began for many of the islands comprising the Pacific and Oceanic region.[6] These crude

early examples were produced in shell, wood, pumice and stone, embellishing many functional objects — masks, smoking pipes, statues, bowls, canoe prows, weaponry and musical instruments. It was a means of depicting the social and religious life, the supernatural forms and cult heroes which determined everyday life, and the transference of spiritual power to these objects. Produced by simple etching tools such as animal bones, pump drills and wooden stakes, these designs were superbly crafted, displaying a uniform balance of colour, form and symmetry.[7]

Due to the location and topography of the Island groups, very few natural resources were readily available, but this did not hinder the production of the artefacts and is testimony to the skill acquired by the Island artisans. Being seafaring people, the Torres Strait Islanders had mastered the sea and its products, so it is not surprising that their greatest achievements were produced with reef materials harvested from the surrounding seas. They manufactured artefacts from the ocean material but they also introduced both the raw material and artefact into the customary exchange network.[8] By this method, the Islanders obtained, in return for their materials, food and artefacts that they could not produce. Goldlip pearlshell, coneshells and plates from the shell of the hawksbill turtle were the most precious commodities exchanged. The turtleshell was the most highly prized and sought after commodity, which was fashioned into not only elaborate ritual masks but also combs, body ornaments, scrapers, spoons and fish hooks.

Masks constructed from turtleshell and wood were the most distinctive and highly embellished of all objects from the Torres Strait artisans. Turtleshell masks were a central component to ritual observance throughout most of the Islands in the Western, Eastern and Central groups but the Top Western Islands also used wooden masks obtained via trade and exchange.[9] Etched and incised using primitive stone axes and animal bones, the low relief carving depicted simple but elaborate design work through animal forms and tracks and clan markings.

Much of the decorative art applied to these masks and implements had Papua New Guinean origins

in common and occurred mostly on flat surfaces due to the implements being used to create them. The central component in the design was firstly positioned and then lightly scratched into the surface of the material being used. The next step was to gouge the lightly scratched lines until they were a few millimetres in depth. The carved portions were then filled with lime and certain parts of the mask coloured using vegetable dyes and ochres. The lime was produced from burnt and crushed shells and the ochre obtained via trade from Cape York Aboriginal tribes.[10]

Ritual use and production of the masks declined with the arrival of the Christian missionaries (in 1871 — known locally as 'Coming of the Light'), eventually ceasing as the Islanders were encouraged to adopt the Christian belief system.

Since its decline at the end of the 19th century, traditional artefact production has been in a state of hibernation. While the Islanders' creations were being removed to the far reaches of the globe, the creators were somewhat more restricted. Because many of the traditional artisans produced work for ritual and religious circumstances, once the Christian belief system was in place their skills in producing these objects were no longer required. Instead their labour was sought for the growing marine industry, either as boat crews or workers in the 'slipways' that were required to build and maintain the growing pearling fleets.[11] Even though pearlshell was a highly prized commodity

Art classes, Mer 1998 photography: Michael Marzik

30

throughout the Islands and was traded extensively through exchange, the monetary benefits obtained from sales to western markets far outweighed any previous value or importance held within the local art and craft market. This caused all traditional craft production to diminish.

In the 1960s and 1970s, researchers aiming at salvaging the remains of traditional knowledge from surviving elders may have inadvertently contributed to the revival of interest in the old ways of life.[12] One Australian historian in particular, Margaret Lawrie, was employed by the Queensland State Library and travelled the Strait extensively, often spending large amounts of time at Island communities, interacting with local people and recording their stories — creation stories about the Torres Strait.[13] Many of these stories are now being retold through the visual arts of contemporary Island artists, especially using the medium of printmaking, considered by many of these artists to be the next true art form, replacing traditional carving.

Makers of new work

New artistic energy has been a result of this historical research and contemporary artists today draw upon this material as a means of reaffirming their identity and their pride, and of replacing the material culture which was removed to western museum institutions over the many years of colonisation. The development of this new artistic movement for the Torres Strait has been led mainly by Island artists residing on the mainland. This group includes Anne Gela, Tatipai Barsa, Ellen José, Dennis Nona, Alick Tipoti and other colleagues.

Anne Gela

Anne Gela was born on Moa (Banks Island), Western Islands Torres Strait in 1953. Her education was obtained on Waiben (Thursday Island) and in 1991 she enrolled at the Far North Queensland Institute of TAFE where she obtained an Associate Diploma in Aboriginal and Torres Strait Island Visual Arts. Although women tended to be drawn more closely to the mediums of batik and ceramics, Gela excelled in the area of printmaking, both linoprinting and screenprinting. Over a ten-year period she has produced many

finely executed prints, two of which (*Koedal: Crocodile hatching* and *Eyes of the sea*, illus. p.40) toured Australia and the United States in the exhibition, *Old Tracks, New Land*. Gela provided the following statement about her work in this exhibition:

> with my crocodile print, I see this as a way of introducing myself to the outside world. My father's totem is the crocodile or *Koedal* in Western Island language. The second print is called *Eyes of the sea* or in our language, *Zobererkep*. This print refers to the Islands that I come from (Torres Strait) and also includes the totems that most Island people have. The designs that you see in the print are taken from the designs of our totem poles and of etchings that are usually done on the conch shells.

The depiction of traditional Island life from a female perspective is the main theme behind Gela's linoprints and in 1998 she was commissioned to reproduce a linocut for the 11th World Congress on Invitro Fertilisation and Human Reproductive Genetics. Gela is currently employed as Arts Coordinator by the SAIMA Torres Strait Islander Corporation in Rockhampton, Central Queensland.

Tatipai Barsa

Tatipai Barsa was born in 1967 and grew up on Mer (Murray Island) on the eastern side of the Torres Strait. He was the first Torres Strait Islander student to gain an Associate Diploma in Aboriginal and Torres Strait Island Visual Arts from the Tropical North Queensland Institute of TAFE in Cairns (commencing his studies in 1986). His images are drawn from his island home and the life of the tropical seas surrounding Mer: the reefs, currents, tides and powerful seas of the Torres Strait. During his childhood, Barsa often spent hours watching at his father's side as sea animals emerged from blocks of *Wongai* wood that were being carved. He inherited many skills and techniques that would later be of great use to him and others. Over the years spent as a printmaker and painter, he has produced, time after time, wonderfully executed works using the medium of printing.

The carved patterns that echo across the surface planes of his work reflect the traditional carving

and plaiting of his people and the vibrant colours that radiate from the fauna and flora found on and around the island. Pictured in many of his prints relating to the sea can be seen many bold line marks that run the length of the linocut, separating the fish. These strong lines represent dangerous currents that surround his island and the shifting of sandbars towards the Central Island group.

Ellen José

With the influx of outside cultures, specifically Pacific Islanders, Torres Strait societies throughout the Islands began to reflect changing language, culture and customs. Island families began to intermarry with the Pacific Island population, thus creating a new race of Torres Strait Islanders with bloodlines to both cultures. With overcrowding starting to occur and with the continual search for work (to sustain the growing size of families) migration to the mainland began in the 1940s. Ellen José's family was one of those migrating. José grew up in and around Cairns during the 1950s and 1960s. After leaving school she worked as a commercial artist and in 1976 was awarded a Certificate of Applied Art from Seven Hills Art College in Brisbane. José continued her studies in Melbourne, gaining a Diploma of Fine Art from Preston Institute of Technology (1978) and a Diploma of Education from the Melbourne State College (1979). José is considered to be the first Torres Strait Islander artist to produce linoprints — these depict tropical island scenes. Being surrounded by Aboriginal and non-indigenous printers she was influenced by both, which is apparent in her work. José also attended printing workshops in Japan where she was greatly influenced by the bold strokes of Japanese artists and the use of handmade and rice paper. Bold lines and geometric shapes cover the black surface of the printed image with the occasional splash of colour applied with watercolour pencils. José is one of few Torres Strait printers to depict the Australian landscape.

Dennis Nona

Dennis Nona was born on Waiben (Thursday Island) in 1973 and spent his childhood at his family's home on Badu (Mulgrave Island). Being of both Torres Strait Islander and Papua New Guinean descent had its advantages for Nona who travelled frequently between both Island groups. In 1990 he travelled to Cairns where he completed his Associate Diploma in Aboriginal and Torres Strait Island Visual Arts at the Tropical North Queensland Institute of TAFE, Cairns.

During time spent at the college, Nona carved and printed many fine works from linoblocks. Comprising intricately cut detail, his main themes were, and still are, based on the creation stories of Torres Strait, the myths and legends and ceremonial practice throughout the Islands. The main images are represented by bold areas of black and are surrounded with traditional markings, motifs and clan totems. Although there were some Torres Strait artists printing before Dennis started on his artistic career path, he was the first to create the finely cut lines and use traditional markings extensively.

In 1995 Nona gained entry to the Australian National University, Canberra School of Art, where he was awarded his Bachelor of Fine Art (Printmaking). Since graduating, he has taken up a number of residencies and held a number of exhibitions throughout Australia and overseas. Last year (2000), utilising his knowledge, skills and networks obtained while in Cairns and Canberra, Nona successfully established a print workshop at Kubin Village on Moa (Banks Island) with assistance from the community council and the Torres Strait Regional Authority. The workshop, which is now called Mualgal Minneral Arts Centre, has already had visits from Theo Tremblay, a well-known Canberra based printmaker. Many of Nona's students are men who had previously developed the skill to carve linoblock through past employment. One such artist working under Nona, Billy Missi, received a Highly Commended Lin Onus Youth Art Prize at the 5th National Indigenous Heritage Art Awards.

Alick Tipoti

The most recognised printmaker from the Torres Strait is a young male artist by the name of Alick Tipoti. Born in 1975 on Waiben (Thursday Island), he began his initial education on Badu (Mulgrave Island) and Ngurupai (Horn Island) before moving to Cairns. He completed an Associate Diploma in Aboriginal and Torres Strait Islander Visual Art at Tropical North Queensland Institute of TAFE

(1995) and a Bachelor of Visual Arts (Printmaking) from the Australian National University, Canberra School of Art, a couple of years later. In 1998 Tipoti entered a large linocut print titled *Aralpaia Ar Zenikula* (illus. p. 36) in the 4th National Indigenous Heritage Art Awards and was awarded the Lin Onus Youth Art Prize. A traditional story from his home island of Badu, it tells a tale of land ownership on the island which resulted in conflict and bloodshed. When asked about his artwork, Tipoti comments:

> I get my inspiration from the ancient artefacts of the Torres Strait Islands, which I have had the opportunity to see in universities and museums, and from the traditional stories handed down and recorded by my father and the recognised elders of the Torres Strait.

In 2000 Tipoti was successful in applying for an Arts Grant from the Australia Council which was used to travel to Cambridge in the United Kingdom to view and study the traditional artefacts of his Torres Strait forefathers. On his return he spent long hours carving linoblocks for a solo exhibition at the Cairns Regional Gallery in early 2001 titled *Lagaw Adthil: Island Legends*. The images reflect the time spent abroad studying the ancient turtleshell masks and artefacts rarely seen after the removal of this material culture by explorers and anthropologists.

A number of prints by Alick Tipoti feature the events of the past, when fighting was glorified and warriors enjoyed the esteem of their people. Legendary heroes appear along with weapons of war, the distinctive shapes of *daris* (headdresses), masks, drums and other artefacts associated with ritual dancing and ceremony. Forceful images of headhunting and the skull racks of warrior cults feature among his recent lithographs and drawings. With the stylisation of forms and narrative undertones, many of his prints, and those by Dennis Nona, are very similar to the storyboards associated with Papua New Guinean culture.

Other significant Torres Strait printmakers are — Laurie Nona (Badu), Brian Robinson (Waiben), Robert Mast (Badu), Mario Assan (Waiben), Rose Barkus (Moa), Fred Baira (Badu),

Nino Sabatino (Kiriri), Nazareth Alfred (Masig), Lorraine Iboai (Saibai) and Kathryn Norris (Waiben).

Printmaking in regional Queensland

Over the past few years there has been an increase in prints being produced by Torres Strait artists throughout regional Queensland, in particular at the Banggu Minjaany Arts and Cultural Centre at the Tropical North Queensland Institute of TAFE in Cairns, the Lockhart River Art Centre and the Mualagal Minneral Art Centre at Kubin Village, Moa (Banks Island). All three centres offer printmaking facilities of an average to high standard and have been visited frequently by recognised faces within the Australian art scene — Theo Tremblay, Yvonne Boag, Garry Shead, Guy and Joy Warren and Arone Meeks.

The Banggu Mijanny Arts and Cultural Centre was established in the early 1980s by a group of dedicated teachers who had grand visions of indigenous art and its place among Australian visual arts. The Centre started its life in an old factory located within the industrial hub of Cairns known locally as Portsmith. After spending several years at this site the Centre was then relocated to the TAFE College.[14]

At the TAFE College, a Vocational Art Certificate program and then an Associate Diploma of Art was established, designed specifically for indigenous people living in remote communities. This course, offering two years of study, suited many of the applicants, both theoretically and practically and gave them an outlet from which they sold work. Although still working under poor conditions and from demountable buildings, this course helped launch many artistic careers for its early students and still does today.

The greatest strength of the course which has put the TAFE College 'on the map' was and still is its dedication to the area of printmaking. Led specifically by Anna Eglitis in the area of linoprinting, monoprinting, etching and recently lithography, other dominant forms that are offered are silkscreen printing (Elaine Lampton), batik (Ian Horn) and ceramics (Cheral Howell and Kerry Grierson). Many of the prints produced from the Centre have now made their way into many

of the state, regional and private collections throughout Australia.

Another centre designed and dedicated to the area of indigenous printmaking is the Lockhart River Arts and Cultural Centre at the Lockhart River Community, which is approximately 800 kilometres north of Cairns. The student artists that combine to form this group are of both Torres Strait Islander and Aboriginal descent and most, though not all, look towards their Aboriginal heritage for inspiration.

The Lockhart River Art Centre's printing workshop was established by Geoff and Fran Barker in 1996 to encourage the use of visual arts as an aspect of cultural development within the indigenous community.

Facilities for painting, etching, silkscreen and block printing are now available through the skilful direction of numerous visiting artists of high acclaim. The artists within this isolated community are now producing works currently sought after throughout Australia and abroad. The strengths of the 'Art Gang' are best illustrated through the huge successes of the participating artists, namely Rosella Namok, Samantha and Silas Hobson, Adrian King, Terry and Leroy Platt, Sammy Clarmont, Fiona Omeenyo and Evelyn Sandy.[15]

Depictions of life, spirituality and environment in and around the Lockhart River region are common themes in the artists' work, executed with a highly graphic and narrative style. Works by the Lockhart River Art Gang are held in the collection of the National Gallery of Australia, Queensland Art Gallery and numerous state and regional galleries.

Still further north, situated on an island in the Torres Strait is the Mualagal Minneral Art Centre established at Kubin Village on the island of Moa in 1999 by Dennis Nona.

Art classes in printmaking and painting are run from the community hall and are offered to all those interested in participating. The artists draw upon their natural surroundings: the island life, dugongs, turtles and a vast array of fish and other marine life which they depict in their works.

This group includes Dennis Nona, Billy Missi, David Bosun, Victor Motlop and others.

Like their Island counterparts residing on the mainland, these student artists utilise their inherited carving skills as they portray the traditional cultural society of Torres Strait in their prints. Being based on Moa, which is situated in the middle of the Strait, access to art supplies is the biggest problem faced by this community and art centre. Basic equipment and supplies are shipped from Cairns ports via barges which take several days to reach Thursday Island and then a further few days before they arrive at Kubin Village.

Despite this setback, the Centre still produces many finely executed prints from carved blocks of linoleum. Based on current outcomes over the past year, the Mualagal Minneral Art Centre's reputation is growing and will continue to grow as the Centre becomes known to more Torres Strait people willing to portray their cultural heritage to the rest of Australia, and to collectors actively seeking new Torres Strait impressions.

The artistic confidence of Torres Strait artists has grown over the past few years with dedicated assistance from individuals and organisations throughout Australia. As more and more prints are produced, a visual history dating from traditional times to present day will start to unfold. The finely engraved, elegant lines with rhythmic movement and varying strokes which carry the eye across the surface are, and will forever be, a trademark from this group of indigenous artists. For a number of people, particularly the younger generation, there is a desire not only to revive the stories of the past for the artists to use as inspiration, but also for all the Islander people, to show the importance of identity — reflecting a renewed interest in the cultural traditions, values and other aspects of the Islanders' unique and rich heritage.

Brian Robinson

1 *Ilan* means 'island' in Torres Strait creole.
2 Tom Mosby, 'Dance Machines from the Torres Strait Islands'
 in S. Cochrane (ed.), *Art ou Artifice* exhibition catalogue,
 New Caledonia: ADCK, 1996, p.11.
3 Tom Mosby, 'Torres Strait Islander Art and Artists' in Tom Mosby
 and Brian Robinson (eds), *Ilan Pasin: Torres Strait art*, Brisbane:
 Cairns Regional Gallery, 1998, pp.87–99.
4 Lindsay Wilson, 'European Exploration and Colonisation in
 Torres Strait' in *Thathilgaw Emeret Lu*, Department of Education,
 Queensland, 1988, p.11.
5 Jeremy Hodes, 'Missionaries and Pearlshellers: Pacific Islanders
 and their influence in the Torres Strait' in S. Cochrane (ed.),
 Art ou Artifice exhibition catalogue, New Caledonia: ADCK,
 1996, p.3.
6 A. Barham and D. Harris, 'Prehistory and Palaeoecology of Torres
 Strait' in *Quaternary Coastlines and Marine Archaeology:
 Towards the prehistory of land bridges and continental shelves*,
 London: Academic Press, 1983, p.541.
7 Lindsay Wilson (1988), p.88.
8 A.C. Haddon (ed.) *Reports of the Cambridge Anthropological
 Expedition to Torres Strait*, vols 1–6, Cambridge: Cambridge
 University Press, 1901–1935.
9 ibid.
10 ibid.
11 Victor McGrath, 'Art and Craft Production post Haddon'
 in *Contemporary Torres Strait Arts (An Overview)*, Oxford: Oxford
 University Press, 1998.
12 Brian Robinson, 'Contemporary Torres Strait Islander Art' in Sylvia
 Kleinert and M. Neale (eds), *The Oxford Companion to Aboriginal
 Art and Culture*, Oxford: Oxford University Press, 2000, p.169.
13 Margaret Lawrie, *Myths and Legends of the Torres Strait*, St. Lucia:
 University of Queensland Press, 1970.
14 Anna Eglitis, 'A New Art from the Torres Strait Islands' in
 S. Cochrane (ed.), *Art ou Artifice* exhibition catalogue,
 New Caledonia: ADCK, 1996, p.27.
15 Paul Brinkman, 'The Lockhart River Art Gang', unpublished paper,
 2000.

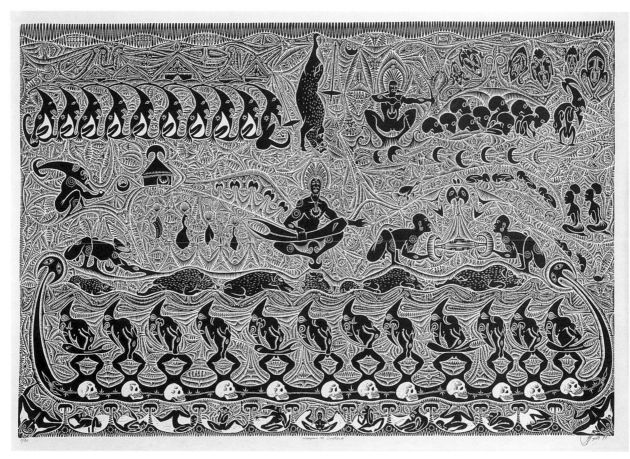

Alick TIPOTI
Aralpaia Ar Zenikula 1998
linocut

Land ownership was of great significance
to headhunters in the Torres Strait back in the
old days. This story is one that occurred before
the London Missionaries brought Christianity
to the islands of the Torres Strait in 1871,
which is known to us as the 'Coming of the
Light'. Today a pig hunter can hunt wherever
he chooses to on the islands without fearing
to lose his life to another warrior. In the past
a hunter on land would be risking his life
hunting outside his boundary. This land which
Aralpaia and Zenikula occupied is located
on Badu (Mulgrave Island) in the Torres Strait,
and the sacred location is very significant
to me and my father because the name Tipoti,
which we carry, is originally from Badu.
Still to this day people on this island view
us as one of the very few natives of this island.

Alick Tipoti

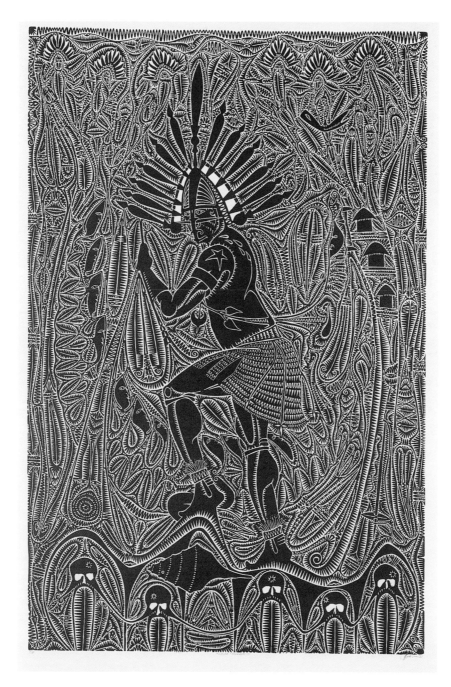

Alick TIPOTI
Kobupa Thoerapeise (Preparing for war)
1999 linocut

Dennis NONA
Boi 1997 linocut, printed in colour

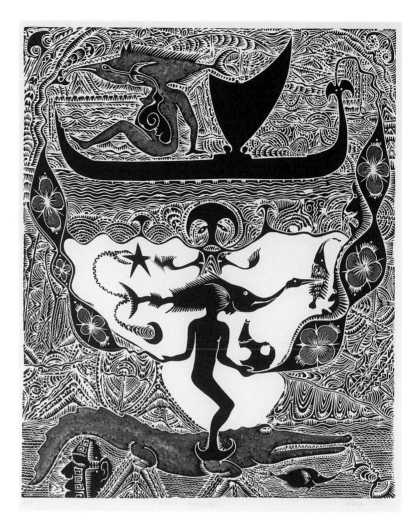

Dennis NONA
Ngaw Kukuwum 1996
linocut, hand-coloured

The girl in this story is from a remote Matuan village in Papua New Guinea called Bora. She moved to the area around Port Moresby while her lover was away. She sent him a message to let him know she was pregnant. Sadly, he was unable to go to her and he couldn't afford to send for her. He wished he could be with her at this time and was hoping for a baby boy, as it would be his first born.

In the print, the pregnant girl is seen sitting on a *lakatoi* (a typical canoe in central New Guinea), wearing a mask representing a fish. She told her lover that she wished she was a fish so she could travel to him. From the end of the canoe, a rope connects them. The rope is made up of hibiscus flowers which represents the connection of love between them.

The boy is seen at the bottom of the print. He wishes he was a bird or fish, so he could fly or swim to her. His mask shows the stars and moon. The symbol above his head is a face mask representing confusion and uncertainty. He holds a traditional cooking pot from her area. The pot contains food which symbolises richness and wealth. His feet are the flying feet of the spirit. The crocodile represents 'crossing over' and the face at the bottom, his lover crying for want of him in her dreams. There are two faces along the rope leading from the cooking pot and these represent her parents who are very upset and angry at their daughter for becoming pregnant before the boy was formally introduced.

Dennis Nona

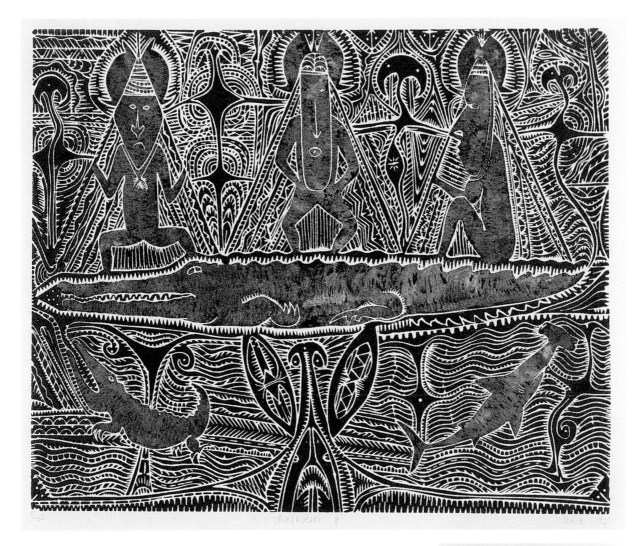

Dennis NONA
Ubirikubiri 1992
linocut, printed in colour

Once upon a time, a large crocodile, called Ubirikubiri, lived in the Mai Kasa river on the western coast of Papua New Guinea.

Ubirikubiri saw three children playing on the riverside. The crocodile pretended to be a log and swam close to the infants.

One of the children saw it and said, 'Oh! look at the big log'. They all ran and swam towards the log and decided to go for a ride, playing and jumping all over it, not realising the danger they were in.

The crocodile floated down the river, heading for the open sea. When they got to the ocean, Ubirikubiri shook the three children off its back and ate them all.

In this print the spirits of the three children are shown riding on the crocodile's back. The symbols separating them represent the river. At the bottom of the print Ubirikubiri is shown when small. The head of a shark is swimming into the scene at the centre bottom of the image. The shark and the hammerheads are attracted by the blood of the young children.

Dennis Nona

Kathryn NORRIS
Dogai figure-head 1996 linocut

39

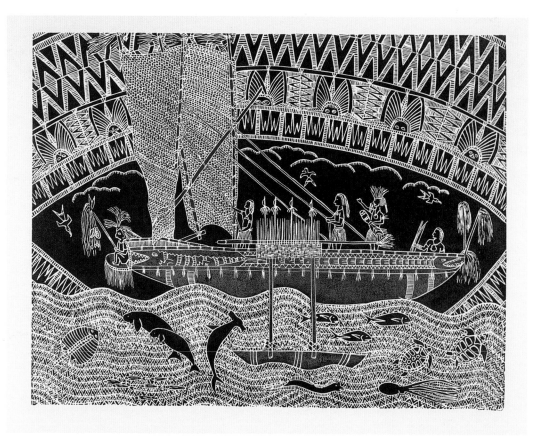

Anne GELA
Eyes of the sea 1993 linocut, printed in colour

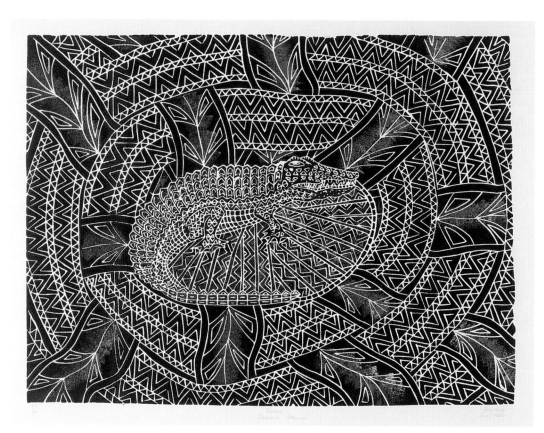

Anne GELA
Koedal: Crocodile hatching 1993
linocut, hand-coloured

This work is a symbolic self-portrait showing
a crocodile hatching from its egg. The *Koedal*
(crocodile) is Anne Gela's totem and she feels
that through her art she has emerged and grown
as a fulfilled woman.

Brian ROBINSON
Ocean spirits c.1996
linocut

Torres Strait Islanders believed that the spirit world had strong control over the natural world and that after death a person would enter the spirit world. Spirits were called upon and pleaded with to assist in the successful outcomes of many daily activities — hunting and gathering, food preparation and harvesting, birth and initiation ceremonies and tribal warfare.

Maidalaig (certain men throughout the communities) were considered to have special powers that enabled them to contact the spirits and it was through these men that requests to the spirits would be made.

Markai (funeral ceremonies) for the dead were regarded as very important events. Male dancers would dance and mime the lifetime actions of the deceased person. Only men were permitted to view the ritual dancing, which they held in *kwods* (sacred places), where they wore large masks constructed from wood and turtleshell. Skulls of the dead relatives were often kept and looked upon as givers of advice and knowledge through dreams.

Ritual cannibalism, another aspect of life closely associated with the spirit world, was widely practised throughout Torres Strait and was of great importance to the Islanders. They believed that by eating certain body parts of the deceased person they would inherit their skills.

Brian Robinson

Brian ROBINSON
Lurking Baidam 1999
linocut, hand-coloured

Regarded as the 'dogs of the sea', sharks are some of the most mysterious and misunderstood creatures in the sea. Referred to as *Baidam* in Eastern Island language, this animal is well respected throughout Torres Strait and is seen as a symbol of law and order. Very keen senses and a large brain size allows them the ability to learn, which makes them excellent hunters of the deep. Sharks play an important role in evolution by removing the weak, hence natural selection and survival of the fittest.

Baidam is one of the eight totems of Mer (Murray Island). It is also the name used for the ancient headdresses worn by initiated men of the Bomai-Malu cult from eastern Torres Strait, a mysterious and feared cult renowned for their exquisite masks made of turtleshell.

Brian Robinson

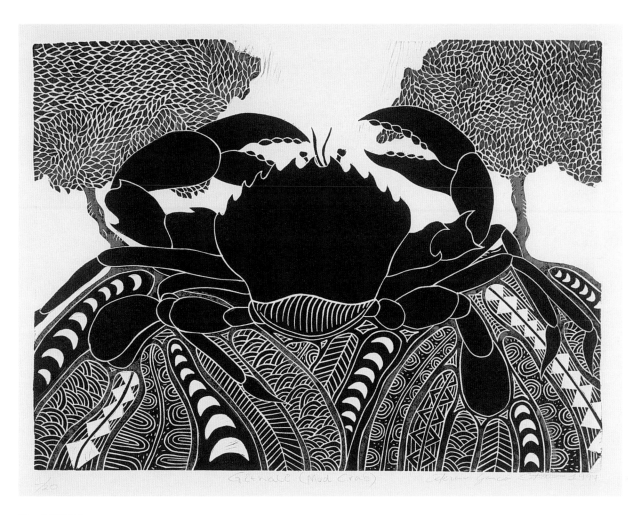

Nino SABATINO
Githali (Mud crab) 1997
linocut, printed in colour

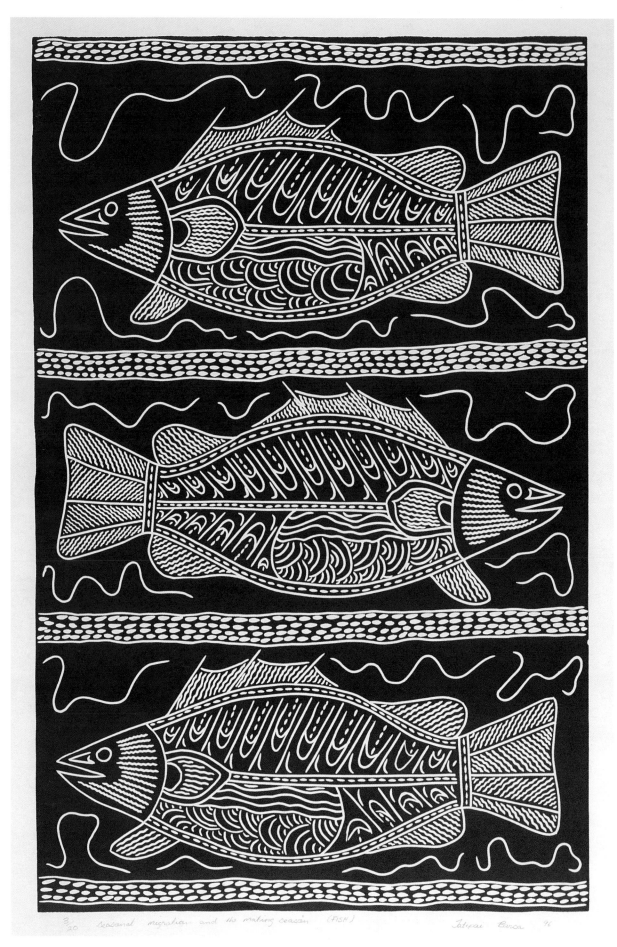

Tatipai BARSA
Seasonal migration and the mating season (Fish) 1996 linocut

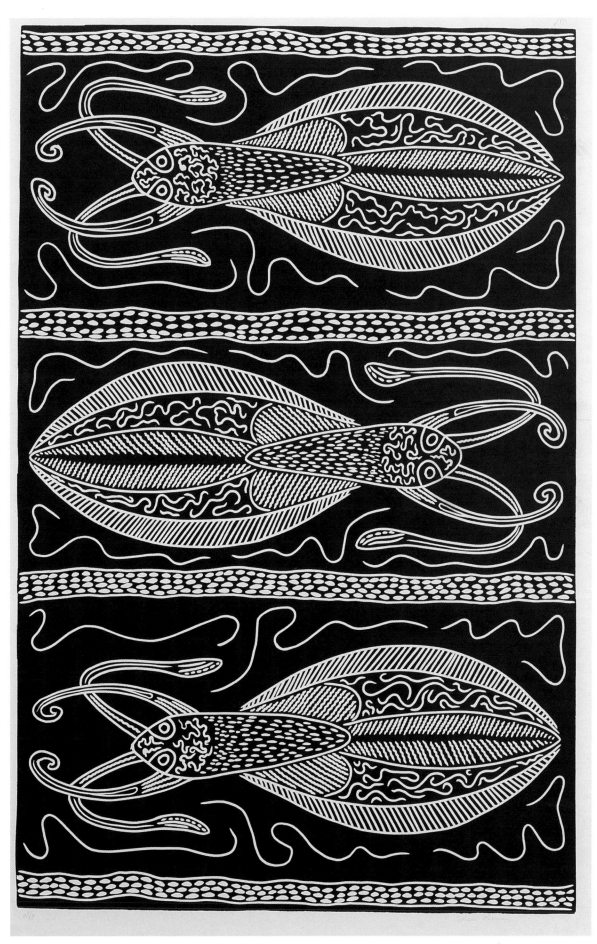

Tatipai BARSA
Seasonal migration and the mating season (Squid) 1996 linocut

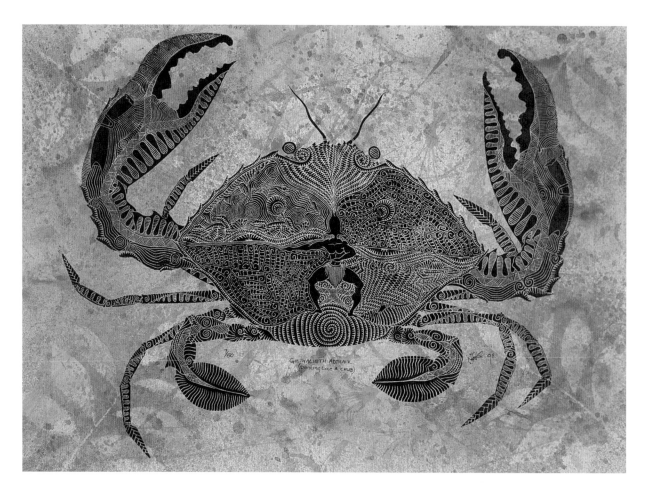

Laurie NONA
Giethalieth Adthaik (Dancing like a crab).
1998
linocut, hand-coloured with stencils

Portrayed in the claws of the crab is the
traditional Torres Strait Islands drum (*warup*)
and the designs around the drum represent
the fast and slow drum beats that guide the
dancers.

The body of the crab is divided into six different
symbolic areas which surround the dancing
warrior. Four of these areas are diagonally
linked and show shells grouped together
representing plenty and sea creatures — turtles,
stingray, shark, fish, and squid — which portray
the food cycle from the mother sea that
surrounds the islands of the Torres Strait.

The design which flows from the eyes
of the crab down into the head of the warrior
represents the cultural knowledge of the elders
seen through their eyes which is passed on from
generation to generation.

At the warrior's feet is a spiral design
representing the holistic power of the culture
being passed on.

Other designs within the crab's legs represent
the different seasons, the wet and the dry.

The overall designs in the image represent
the knowledge that is passed from family elders
to their children's children.

Laurie Nona

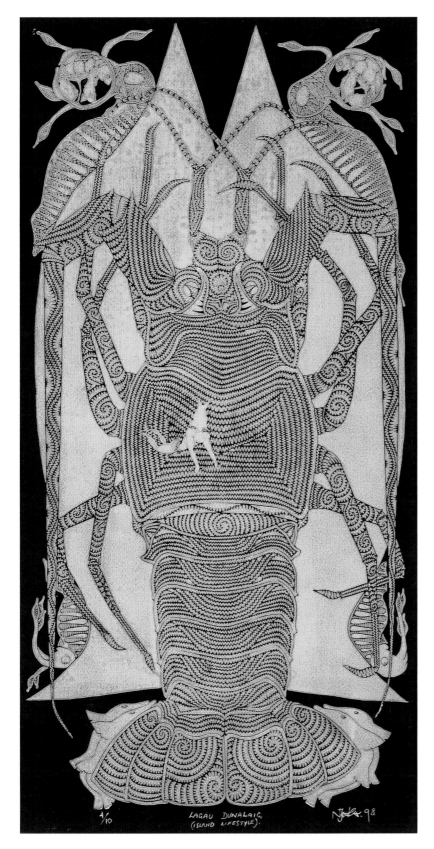

Laurie NONA
Lagau Dunalaig (Island lifestyle)
1998 linocut

The flared tail of the crayfish
The design and pattern represent the two sea
currents in the Torres Strait that determine the
times at which the people of the Torres Strait
can hunt and gather crayfish, dugong, turtle,
fish and shells. On either side are two shovel
nose sharks which symbolise these currents.
In my language the currents are *Guthath* and
Kulice.

The body of the tail
The six sections symbolise the six dialects
of the Strait. The design in these sections
represents the human tongue.

The last section between tail and head
The tight spiral represents the old culture of our
people — that is emotionally centred in every
person in the Strait — a strength of culture.

Mid section of the head with warrior image
This area represents the tensions of living
in a white society, obstacles we have to learn
about to survive in white society — it is the
stress that drives our young people to crime,
who live away from their islands — on the
mainland — without their culture they turn to
crime.

The young warrior represents the Torres Strait
people on the mainland who grow up without
their culture. The young warrior in my print is
waking up to realise that he must refine his
culture symbolised in the designs all around him.

The Dan (Headdress)
The solid white area is the shape of the Torres
Strait Island headdress worn by the cultural
dancers nowadays, and worn by the warriors
in the old days.

The legs of the crayfish
The patterns in the part of legs closest to the
body represent the pearl shell, the patterns in
the bottom section before the feet depict the
trochus shell.

The eyes of the crayfish
The eyes are also the eyes of the Torres Strait
Island pigeon, which is symbolised in the
patterns that flow up the feelers' first section
until meeting a coconut leaf design and a
small section representing a mud crab and
another coconut leaf.

The patterns on the antenna
These represent the flow of coral sea and sea
cucumbers.

Other designs within this print are two squid
holding turtle eggs at the top of the crayfish,
on their bodies are patterns representing turtle
tracks, and the two feelers at the mouth of the
crayfish which represent the shark.

Laurie Nona

47

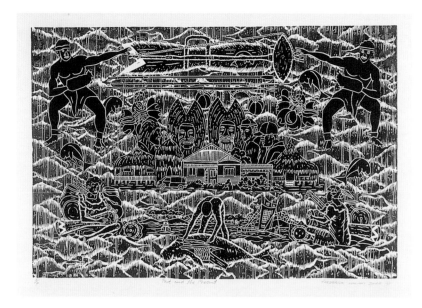

Frederick BAIRA
Past and the present 1997
linocut, printed in two colours

This work shows the ways the old culture
of the Torres Strait is slowly changing and being
eroded by the new (modern) culture of today.

The centre of the design features the images
of traditional island homes situated beside
a suburban house, the likes of which can be
seen all over Australia. Above the dwellings,
island warriors wearing traditional *dari*
(headdresses) are depicted beside today's
island men wearing modern hats.

In the foreground, a dugong is being prepared
for a feast as was done in the old days. It still
remains a favourite food for the Torres Strait
Islanders today.

The repeating pattern that forms a background
linking the main images is the *Bu* or trumpet
shell. The *Bu* was used in the old days to
summon people for special occasions like
weddings, feasts and dancing. It was also
used to summon people to church after the
missionaries came, because there were no bells
in the early days.

The sound of the *Bu* is still used today in Island
dance performances. The print depicts this
tradition with the dancers shown at the top
of the picture. Below the dancers, two women
can also be seen beating traditional *warups*
(drums).

Frederick Baira

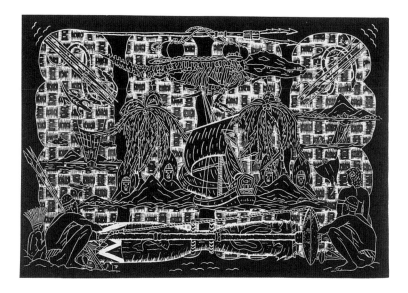

Frederick BAIRA
Invaders II
1997 linocut, printed in two colours

Invaders II shows where the massacres
occurred. Massacres of the Islanders only
occurred in the Eastern Islands. This print
shows how my forefathers watched as the
First Fleet invaded the Torres Straits.
The warriors' fighting tools were no match
for the weapons used by the invaders.

Frederick Baira

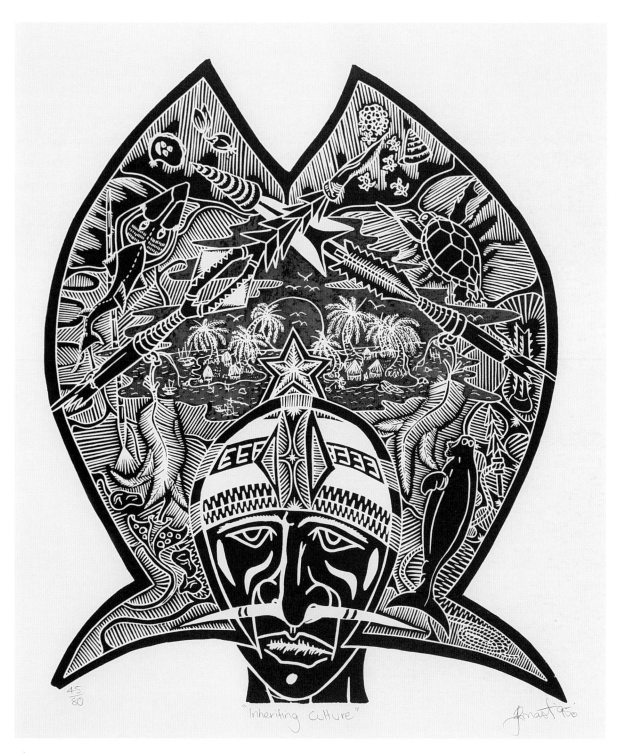

"Inheriting Culture" 45/80

Robert MAST
Inheriting culture 1994
linocut, printed in colour

I feel it is very important that young people
start learning about their culture and
environment and preserve, show and enforce
it for generations to come.

Robert Mast

Ellen JOSÉ
Landscape 1987 linocut

Ellen JOSÉ
Seascape 1987 linocut, printed in colour

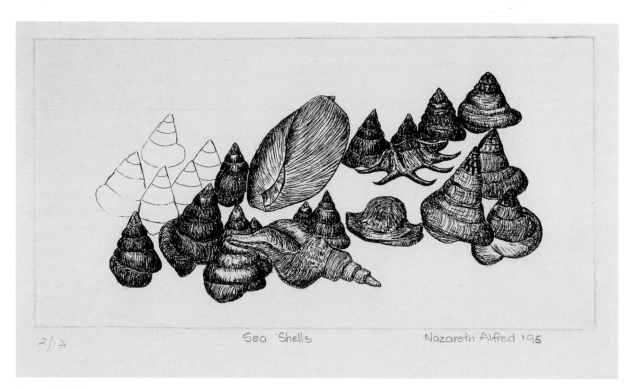

Nazareth ALFRED
Sea shells 1996 etching

My artistic expression explores my identity,
which is maritime based and through my work
I am connected spiritually to the land and sea
of my ancestors. My inspiration comes from the
sea. My art is part of my culture and is not
separated but is merely an element which
makes up the whole.

Nazareth Alfred

Limited edition printmaking was introduced into Papua New Guinea in the late 1960s and reached its peak of popularity in the 1970s. The practice began to fade in the 1980s and has now virtually disappeared. The prints produced belong to a specific period of social, political, artistic, literary and educational change in Papua New Guinea. Created by artists from a diversity of backgrounds, the works present strong and vibrant images that continue to resonate.

On 21 November 1969 an exhibition of woodcuts by Mathias Kauage and screenprints by Taita (Marie) Aihi and English expatriate Georgina Beier opened at the University of Papua New Guinea's Centre for New Guinea Cultures in Port Moresby. The show, probably the earliest to include prints by Papua New Guinean artists, was organised by Georgina and Ulli Beier.

Aihi, a Roro woman from Waima, was 18 years old and had lived most of her life on Yule Island Catholic Mission when she met Georgina Beier and was encouraged to pursue a career in textile design in Port Moresby. Kauage, on the other hand, had tracked down an initially dubious Georgina Beier after finding inspiration in an exhibition of drawings by (Timothy) Akis which she had organised in February 1969. Akis' exhibition was extraordinary not only because the artist, from Tsembaga Village in the Simbai Valley, Madang Province, had started drawing seriously just six weeks before the show opened, but also because it was essentially the first exhibition of 'contemporary' art by a Papua New Guinean artist.[1]

Contemporary or 'new' art using imported techniques and materials is largely an urban concern in Papua New Guinea, with work carried out either in dedicated municipal settings, or in specific schools and cultural centres outside of them. The reasons for this are practical as well as cultural; it is in those places that the necessary equipment and materials are most readily available and 'artist' as a personal career choice was not, until recently, part of Papua New Guinean culture. While those with exceptional artistic skill were acknowledged and appreciated, they also participated in the everyday activities demanded by culture and survival.[2] As writer, researcher and collector of Papua New Guinea's contemporary art, Hugh Stevenson put it: 'The idea of a person exclusively subsisting by art production and dedicated in his thinking only to art would have been exceptional'.[3]

During the 1960s Akis worked intermittently as an interpreter and source for a number of anthropologists, drawing in order to communicate designs or ideas that were difficult to describe in pidgin. Georgida Buchbinder, an anthropologist from Columbia University, was taken with Akis' sketches and, when he travelled with her to Port Moresby in January 1969, showed his work to Georgina Beier who she suspected would find them intriguing. Aware of his potential, Georgina Beier encouraged Akis in his drawing.

Georgina Beier, a London-trained artist, and her academic husband Ulli Beier, had been involved in fostering and promoting contemporary African art, primarily in Nigeria, before relocating to Papua New Guinea in 1967. Art brut was also of interest and shortly after arriving in Port Moresby Georgina Beier became involved with patients at Laloki Mental Hospital, bringing them art materials in the hope that creative activity might boost their spirits.[4]

In the short time he spent in Port Moresby, Akis produced more than 40 drawings and a number of batiks. The works formed the basis of his inaugural exhibition. In his introduction to the exhibition Ulli Beier wrote:

> The delicate freshness of these drawings owes nothing to the traditions of his people, whose artwork consisted mainly of geometric shield designs. Unburdened by the rigid conventions of ancient traditions and uninhibited by western

education, Akis created his personal image of a world of animals and men.[5]

Following the show, Akis went back to his village and did not return to Port Moresby until 1971. From then until his death in 1984, his time was divided between subsistence farming in the village and short periods of intensive work in Port Moresby. Although a successful and prolific artist in the capital, he appears to have made very few drawings at home.

In November 1969, a number of Akis' earliest drawings were reproduced in the maiden issue of *Kovave: A journal of New Guinea literature.* Conceived by Ulli Beier, who lectured in literature at the University of Papua New Guinea, the literary periodical also provided exposure for contemporary art. Each issue included illustrations and discussion of an artist's work as well as artist-designed vignettes. Kauage, Aihi, Kambau Namaleu Lamang, John Man and the sculptor Ruki Fame, among others, had work published in *Kovave.*

Kauage was one of a number of Highlanders working as labourers in Port Moresby who were invited to the opening of Akis' first exhibition in order that the artist should not feel like a spectacle amongst the otherwise largely expatriate audience.[6] Spurred on by the work, Kauage, from Mingu No.1 Village, Gembogl in Simbu, had a friend deliver some of his own drawings to Georgina Beier. Unimpressed by the pictures she guessed to have been copied from schoolbooks and magazines, she later wrote, 'they must have looked to the artist tremendously slick, almost identical to the real thing on the overpoweringly prestigious printed page'.[7] Nevertheless, she agreed to meet Kauage and the two formed an enduring friendship. Georgina Beier coaxed Kauage to draw from his imagination rather than copy 'realistic' illustrations and he soon gave up his job to concentrate on art. His style changed and developed quickly, reflecting his state of mind.

Now Papua New Guinea's best-known contemporary artist, Kauage regularly exhibits internationally and has work in collections worldwide. He was a joint winner of the Blake Prize

for Religious Art in 1987 and in 1997 was awarded an OBE (Order of the British Empire) by Queen Elizabeth II for his services to art. A short time into his artistic career, however, Kauage's spirits fell and he began drawing heavy, blocky and sometimes limbless figures. It was then that Georgina Beier taught him to make woodcuts.

> At this stage I introduced the woodcutting technique. His new, heavy, solid shapes were easily adaptable to this technique. (His earlier, flowing line would have been ideal for etching but I did not have the facilities for this.) One reason why I introduced the new technique was that Kauage — who had now given up his job as a cleaner and lived much better on the sale of his drawings — had time on his hands. Kauage wanted to put in a full day's work, and no artist, however imaginative and prolific, can go on producing new ideas for drawings all day long, every day. The woodcuts allowed him to relax a little. He produced very fine work in this medium, but somehow he could not shake himself out of the depression completely.[8]

Ten woodcuts were printed in small editions, impressions from which were shown at the print exhibition in November 1969 (illus. p.58). Kauage's woodcuts featured creatures and riders and geometric shield patterns. Initially ashamed to admit they came from his imagination, the artist is reported to have claimed the amazing images of stylised people floating above heavily decorated horses, goats and snakes were accurate depictions of scenes he had witnessed. The woodcuts and a number of other important early prints, including screenprints of Akis' work and Aihi's prints and textiles, were made at Ulli and Georgina Beier's Port Moresby home, many in a backyard shed — called the 'Centre for New Guinea Cultures' — provided by the University of Papua New Guinea. Screenprinting from hand-cut stencils was the most commonly used technique. In 1971, however, Georgina Beier stated that she would have liked to teach Akis etching:

> Pen and ink drawings provided a near perfect medium for Akis, but ideally he might have learned etching. His style demands the delicacy and soft dense texture that only etching can give. But unfortunately we had no etching press available.[9]

In fact, in the late 1970s a print technician at the National Arts School created a makeshift press and printed a small group of etchings taken from Akis' drawings. Two impressions from the experimental printing are in a private collection in Canberra. Due to a lack of facilities, very few etchings by artists from Papua New Guinea are known, although there is an extremely fine and rich etching and aquatint of a pig by Jakupa Ako, *Wild pig* from 1983, in a private collection in Sydney.

A significant proportion of limited edition prints from Papua New Guinea were made at the National Arts School. The institution, established in 1972 as the Creative Arts Centre, grew out of the Centre for New Guinea Cultures and was expanded and renamed the National Arts School in 1976. The name change was accompanied by an increase in funding and was one of many cultural initiatives that occurred around the time of Papua New Guinea's Independence, declared on 16 September 1975.

Even before the creation of the Creative Arts Centre, however, printmaking was taught at Goroka Teachers College, at that time the only secondary teachers college in Papua New Guinea, and possibly also at Goroka Technical School where the curriculum included commercial design. At Idubada Technical College School of Printing and Design in Port Moresby vocational courses were taught in design, photomechanical printing, photography and commercial art. In addition, in the 1970s, some woodcut printing and stencil screenprinting was done at Sogeri Senior High School, near Port Moresby, Kerevat Senior High School, near Rabaul in East New Britain, and at Port Moresby Teachers College.[10]

At the National Arts School screenprints and photo-screenprints dominated but occasional woodcuts, linocuts and monotypes also appeared. According to Maureen MacKenzie-Taylor, who taught graphic design at the National Arts School in Port Moresby from 1977 until 1981, the reasons for the proliferation of screenprints produced in Papua New Guinea in the 1970s and early 1980s are largely practical. The techniques taught reflected the available facilities and the skills of the mostly expatriate teachers and screenprinting predominated as a versatile and relatively uncomplicated technique.[11]

Following its use to print posters by political and community groups in the 1960s and 1970s and its 'discovery' around the same time by well-known artists like Andy Warhol, Richard Hamilton, Robert Rauschenberg and Roy Lichtenstein, screenprinting was also fashionable. In addition to limited edition artists' prints, screenprinting was used to print the invitations, advertising posters and often the catalogue covers associated with the regular exhibitions of work by artists at the Creative Arts Centre/National Arts School.[12]

When the Creative Arts Centre was established in 1972, Tom Craig, a Scottish expatriate who had been in charge of 'Expressive arts' at Goroka Teachers College, was appointed Director. Students were encouraged to value and explore their cultural heritage and to express themselves through drama, dance and music as well as the visual arts. In addition, efforts were made to counter the negative art education many students had experienced previously, including schooling that focused on realistic 'picture book' illustrations according to an Australian syllabus. Some students had already participated in courses that incorporated the use of local designs, while others had been exposed to vehement disparagement of their artistic inheritance. In 1976 Craig wrote of the Creative Arts Centre:

> It is hoped that in such an environment, where formal teaching is kept to a minimum; where art is regarded as an activity and an attitude of mind – not a discipline to be learned; where traditional skills mingle with modern technology; there will develop a form of contemporary expression which is genuinely Papua New Guinean.[13]

As they had been in Goroka, traditional and established contemporary artists, including Akis, Kauage, Jakupa and Fame, were invited to work at the Centre as artists-in-residence. The arrangement was described by Craig:

> Artists-in-residence at the Centre are given free accommodation, a living allowance, and all necessary equipment and materials. There are no prerequisite entry qualifications and scholarships are continued for as long as

the staff and students agree that the experience is beneficial. Traditional painters, carvers, musicians and dancers are invited to the Centre for varying lengths of time to work alongside the students.[14]

The first artists to work at the Centre were Kambau Namaleu Lamang and the illustrators John Dangar and Jimmy John. Other artists who worked there, most initially as students, include John Man, Cecil King Wungi, Wkeng Aseng, Joe Nalo, Martin Morububuna, Stalin Jawa, Jodam Allingham, David Lasisi and the sculptors Gickmai Kundun and Benny More.[15]

As well as nurturing the original work of Papua New Guinean artists, the Creative Arts Centre/National Arts School was concerned with exhibiting and raising the profile of work produced there. The exhibitions were well promoted and frequent and works of art were available for sale, with 50 per cent of the profits going to the institution to cover the costs of materials. The introduction of photo-screenprinting equipment in 1975 meant that prints, particularly

prints of drawings, could be easily produced using the technology. Photo-screenprints provided multiple items that could be sold at lower prices and in greater numbers than other work. Nevertheless, hand-cut stencils continued to be used for very large prints and by those with an interest in printing. However, as Stevenson mentioned: 'Later, when profits from school activities went into the government consolidated revenue, the number of exhibitions and the production of prints declined.'[16] In 1985 a special posthumous printing of a number of Akis' works took place at the National Arts School. The photo-screenprints, along with some remaining drawings, were exhibited and sold at the School in order to raise money for the artist's family.

Students and artists working at the Creative Arts Centre/National Arts School rarely created their own screens or printed work themselves. For many artists, prints were an aside rather than their principal form of expression, and quite a number of contemporary artists did not make prints at all.[17] The practical aspects of print production

Covers of *Papua Pocket Poets*, Port Moresby: 1972 and 1973

were carried out by the graphics teaching staff, including Bob Browne, Maureen MacKenzie-Taylor and Kriss Jenner (Stocker) and by the technicians at the school, particularly Apelis Maniot, Bart Tuat and Kambau.

Man, Morububuna, Kauage, Jakupa, Kambau and Lasisi are among the artists who, at various stages in their careers, dedicated considerable effort to printmaking. Morububuna, from the Trobriand Islands, began working at the Creative Arts Centre in 1974 when he was 17. The style of his early work, which consists mostly of screenprints, lithographs and woodcuts, reflects his training in Trobriand wood carving under his grandfather, a renowned wood worker. Many of Morububuna's prints illustrate stories from the Trobriand Islands using stylised motifs and imagery from the region. Two of his screenprints, *The death of Mitikata* and *Boi* (illus. p.70), were editioned in carefully worked multicoloured versions as well as in simple single colour prints. The works were described by art historian Susan Cochrane in her book *Contemporary Art in Papua New Guinea*:

> *The death of Mitikata* is an elegy to the paramount chief of the Trobriand Islands: the group of figures at the *sagali* (mourning ceremony) are enclosed in the shape of a *tabuya* (canoe prow board), surrounded by the curvilinear motifs of *kula* canoe carvings. In *Boi*, he has drawn the profile of the sea hawk, which, in an abstracted form, is one of the primary symbols in the art associated with *kula* (ceremonial exchange cycle). In a clever inversion, Morububuna presents the realistic bird shape, but infills it with other detailed motifs and symbols, drawing on Trobriand iconography and his own.[18]

Morububuna shared studio space with John Man and in 1975 they held a joint exhibition of prints, *Man & Morububuna*. Man, from Golmand Village in the Simbai Valley of Madang Province, took up drawing in the early 1970s and applied to the Creative Arts Centre in 1973 after hearing of the success of other Highland artists. A student at the Centre from 1974 to 1976, Man worked in Port Moresby until 1983 when he returned to Madang and continued to produce prints.

Man's 1974, *Taim ol Dok i opim maus na karai nongut turu long kaikai* (The time all the dogs opened their mouths and howled because there was nothing to eat), a screenprint with areas of hand-applied colour, depicts a group of stylised creatures with wide open mouths. The careful, tendrilous work comprising fine lines and spirals probably relates to one of the many Simbai stories Man drew inspiration from throughout his career. Man's designs relating to legends are used to show relationships between elements and are symbolic rather than illustrative or narrative and can therefore be difficult to interpret.

Lasisi worked at the Creative Arts Centre/National Arts School from 1975 until 1979. For Lasisi, who had studied art at Sogeri Senior High School, screenprinting was his chosen medium. His first solo exhibition, and the launch of his book of creative writing with counterpart screenprints, *Searching,* took place at the National Arts School in 1976, where 32 strikingly graphic screenprints were shown.[19] In his introduction to the exhibition, graphics lecturer Bob Browne wrote:

> Since his arrival at the Centre David has been struggling, as many young people do, to discover his own identity and somehow relate his village traditions to this changing society. Clearly these traditions are well established in his personality — so is Bob Dylan. David's search is shown in these prints, and especially in his book. David is fortunate. He has the ability and the opportunity to express his feelings in written and visual terms.[20]

Like Man and Morububuna, many of Lasisi's prints and stories relate to legends from his birthplace, Lossu in New Ireland. Others, however, reference popular culture and the turmoil of unrequited love. *Samkuila*, which shows a stylised fish within a denticulate and heavily decorated ovoid shape, describes a clan legend telling the tale of a fish which was given to a female ancestor and can now be seen in the river in the Samkuila clan's land (illus. p.63)

By the 1980s much of the idealism and excitement of the 1970s was lost. The ebullience and optimism of the years surrounding Independence seemed to have transformed

into division and disappointment. Less money was available and many of the expatriates who had been supportive of printmaking, and contemporary art in general, had returned home. The National Arts School became run down and information about artwork being created elsewhere harder to find. In 1989 degree level courses, taught in conjunction with the University of Papua New Guinea, were brought in at the National Arts School and in 1990 it was absorbed into the University. In 1997, Cochrane wrote:

> Amalgamation with the University caused some consternation, particularly as it has reduced access for people with visual skills but no formal education to a conducive environment where they could develop their skills and exhibit work. While some of the earlier graduates are now on the faculty staff — Gickmai Kundun continued as the lecturer in sculpture and Jodam Allingham was head of visual arts 1992–1993 — they have their positions because they had obtained higher degrees. Other established visual artists who hold the National Art School's Diploma in Fine Arts and had been employed as instructors, including Joe Nalo, Martin Morububuna and Stalin Jawa, were dismissed as it was held that their academic qualifications were not high enough for university requirements.[21]

Despite events like the 1998 handover of a European Union funded arts complex, named 'The Beier Creative Arts Haus' in recognition of Ulli and Georgina Beier's contribution to contemporary Papua New Guinean art and culture, the enthusiasm of the earlier era has not returned. Creative Arts Department staff and programs have recently been cut due to a shortage of funds and work has essentially ceased.[22]

At present there is nowhere to exhibit in Port Moresby and artists, including Kauage, are forced to hawk their work outside hotels in the city. Artists now working in Port Moresby — Kauage, Oscar Towa, John Siune, Apa Hugo, Gigs Wena, James Kera, Maik Yomba, Alois Baunde and Simon Gende — produce paintings, mostly in gouache, as well as some drawings. Printmaking has been precluded by the materials, facilities and support it requires.[23]

The lively limited edition prints produced from the late 1960s until the mid-1980s by artists like Kauage, Kambau, Lasisi, Jakupa, Man and Morububuna, therefore, mark a distinct and vital period in the history of contemporary art in Papua New Guinea.

Melanie Eastburn

With thanks to Ulli Beier, Hugh Stevenson, Maureen MacKenzie-Taylor, Helen Dennett, Michael Mel, Kriss Jenner and Barleyde Katit for generously sharing with me their time, expertise and knowledge. Special thanks go to Gordon Darling, not only for making this work possible through the Gordon Darling Fellowship, but also for his considerable support and enthusiasm.

1 The use of the term 'contemporary' to describe recent art work created using imported materials and techniques is in no way meant to imply that continuing long-established art forms such as carving, pottery, *bilum* (string bag) making or tapa painting, whatever their purpose, are any less dynamic or contemporary.

2 Georgina Beier, 'Modern Images from Niugini', *Kovave* special issue, Brisbane: Jacaranda Press, 1974, pp.3–4; Susan Cochrane, *Contemporary Art in Papua New Guinea*, Sydney: Craftsman House, 1997, p.119.

3 Hugh Stevenson, 'Structuring a New Art Environment', in H. Stevenson & S. Cochrane Simons (eds), *Luk Luk Gen! Look Again!: Contemporary art from Papua New Guinea*, Townsville: Perc Tucker Regional Gallery, 1990, p.25.

4 The artists — including Sukoro, Mattias, Kupialdo, Hape and Tiabe — produced paintings, drawings and screenprints. The screenprints were printed in small editions in a workshop at the hospital and all screens were created by hand. In order to protect their identities, the full names of the patients were not revealed.

5 Ulli Beier quoted in Cochrane (1997), p.48.

6 In a discussion about the audience for contemporary art in Papua New Guinea, Bernard Narokobi, a politician and long time commentator on Papua New Guinea's culture, wrote:
> Contemporary Papua New Guineans rarely buy contemporary art. There are several reasons for this. The most obvious is that few have money to buy works of art. They rarely see it as a possible economic asset, and they tend to regard contemporary art as the intriguing meanderings of an individual artist. Most Papua New Guineans with attachment to tradition associate themselves with their own tribal images. They see new images as belonging to 'others'.

Bernard Narokobi, 'Development of Contemporary Art in Papua New Guinea', in Caroline Turner (ed.), *Tradition and Change: Contemporary art of Asia and the Pacific*, University of Queensland Press, 1993, pp.166.

7 G. Beier (1974), p.10.

8 G. Beier (1974), p.13.

9 G. Beier (1974), p.9.

10 Stevenson, 'Structuring a New Art Environment', pp. 25–28; *Tenpela Krismas: National Arts School Tenth Anniversary of Independence Retrospective Exhibition*, Port Moresby: National Arts School, 1985, introduction; Hugh Stevenson, letter to author, 28 June 2000.

11 Maureen MacKenzie-Taylor, personal communication, 14 June & 16 August 2000.

12 The themed promotional ephemera that accompanied exhibitions was itself often inspired. For instance, the invitation to Akis' 1977 exhibition at the National Arts School, designed by Maureen MacKenzie-Taylor, was printed with an image adapted from one of Akis' drawings, *Palai*. The card could be cut and folded to create one of his extraordinary lizard creatures in three dimensions. Similarly, the 1977 Kauage exhibition at the School featured both an invitation and a giant aeroplane-shaped banner hung outside the exhibition space based on Kauage's cartoon-like screenprint, *Balas long ples balas* (Plane at the airport).

13 Tom Craig in *Jakupa,* Solander Gallery, Canberra and Creative Arts Centre, Port Moresby, 1976 (exhibition catalogue) p.[4].

14 Craig (1976), p.[3].

15 Some artists who had worked with Georgina Beier, particularly William Onglo and Barnabus India, chose to remain independent of the Creative Arts Centre/National Arts School.

16 Hugh Stevenson, letter, 28 June 2000.

17 Joe Nalo, who studied and taught at the Creative Arts Centre/ National Arts School and is currently Curator of Contemporary Papua New Guinea Art at the Papua New Guinea National Museum and Art Gallery, first exhibited in 1969 and continues to paint but has never been actively involved in printmaking. Lithographs of some of Nalo's paintings have recently been printed in Germany. Hugh Stevenson, personal communication, 5 July 2000; Eva Raabe, 'Understanding Pacific Identity and Individual Creativity: Two paintings from Papua New Guinea', in *Art Monthly Australia*, July 1999, p.23.

18 Cochrane (1997), p.60.

19 Technical staff and other students at the school, including Apelis Maniot, Daniel Amos, Osten Harupa and Kingsley Dikuwola, assisted Lasisi in creating the prints.

20 Bob Browne, introduction to *Searching,* Boroko: National Arts School, 1976 (exhibition catalogue) p. [1].

21 Cochrane, (1997), pp.37,38.

22 Barleyde Katit, personal communication, 2 August 2000.

23 Hugh Stevenson, personal communication, 5 July 2000; Helen Dennett, personal communication, 20 July 2000, 'Editorial: The sorry state of arts in Papua New Guinea', *Post Courier*, Port Moresby, 22 December 1998. Outside of Papua New Guinea prints of Kauage's work have been produced more recently with the help of Georgina and Ulli Beier.

PRINTS FROM PAPUA NEW GUINEA

Mathias KAUAGE
Plank bilong pait (Fighting shield) 1969 woodcut

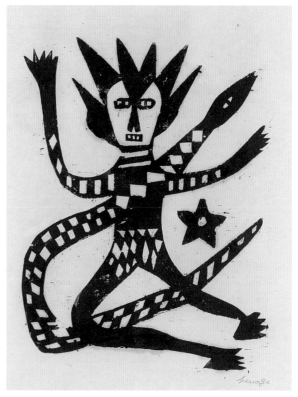

Mathias KAUAGE
Tupela wokabaut (Two go for a walk) 1969 woodcut

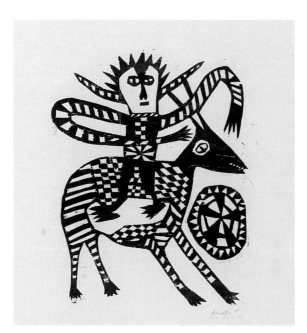

Mathias KAUAGE
Meme bilong mi (My goat) 1969 woodcut

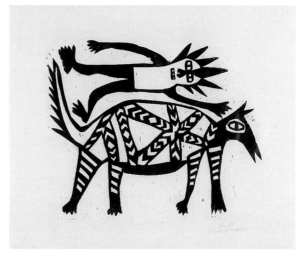

Mathias KAUAGE
Untitled 1969 woodcut

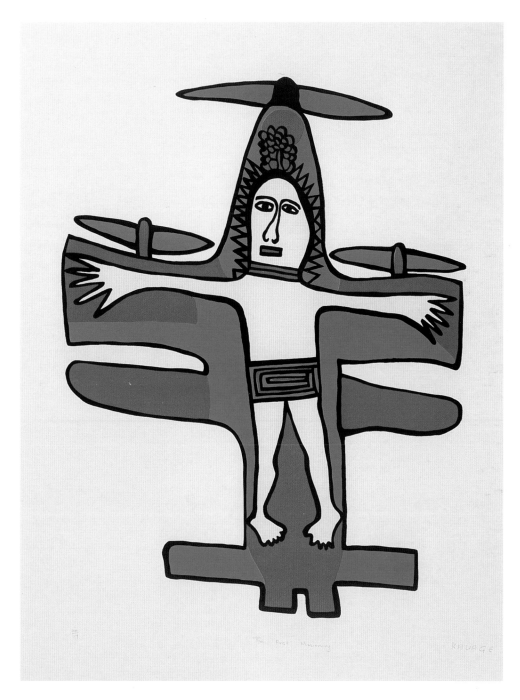

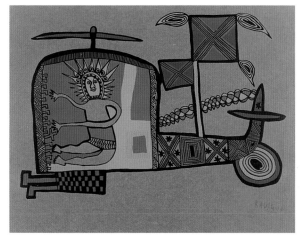

Mathias KAUAGE
Helicopter 1974 screenprint

Mathias KAUAGE
The first missionary 1977 screenprint

In the catalogue for the 1977 exhibition at the National Arts School in which this work was shown, it was accompanied by the following story:

Bipo ol wait man misinari i no kam yet, dispela namba wan misinare i kam olsem pisin long Madang na i go daun long Simbu klostu long Mt Wilhelm. Dispela nambawan misinari nem bilong em Father Sepa em i kam long hap bilong mipela na bihain i go raun long plati ol hap. Mipela olgeta i ting em wanpela bikpela pisin I kam nating.

Before all the white missionaries came, this one missionary came by himself like a bird from Madang and landed at Bundi station and later landed in Simbu close to Mt. Wilhelm. This missionary called Fr Tropper came to our area for a time and then went to many different places. We all thought he was really a big bird, coming out of the blue.

Mathius Kauage

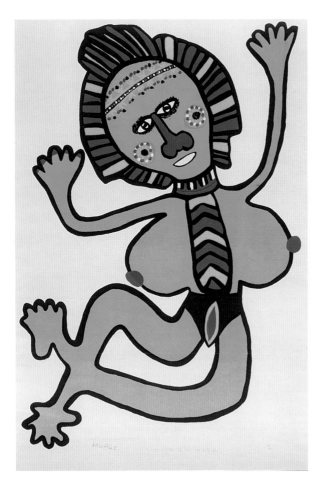

Mathias KAUAGE
O meri wantok mi seksek long you (Hey lady, I fancy you)
1977 screenprint

In the catalogue for the 1977 exhibition at the National Arts School in which this work was shown, it was accompanied by the follwing story:

O meri Simbu bipo you pasim purpur, toti na pikgris pulap long gras bilong yu, nau yu bilas gut tru na putim trausis na banisim susu, na plai go daun long Kundiawa na pulim ai long ol masta.

Simbu woman before you wore a grass skirt with dirt and pig grease in your hair. Now you wear trousers and a bra and race off to Kundiawa to try to attract European men.

Mathius Kauage

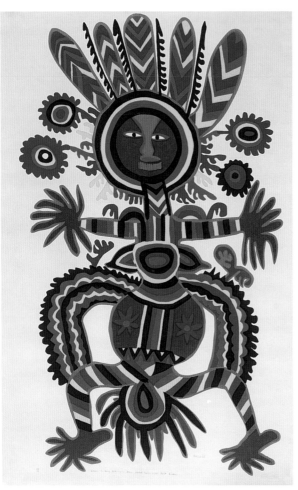

Mathias KAUAGE
Meri i wari (Worried woman) 1978 screenprint

In the catalogue for the 1978 exhibition at the National Arts School in which this work was first shown, it was accompanied by the following story:

Bilum bilong pikinini ikam autsait taim meri i laik pispis. Em i pilim nogut tru na wari wari nogut tru na krai i stap.

When she was trying to urinate the placenta came out.
She felt really awful and was very worried, so she cried a lot.

Mathius Kauage

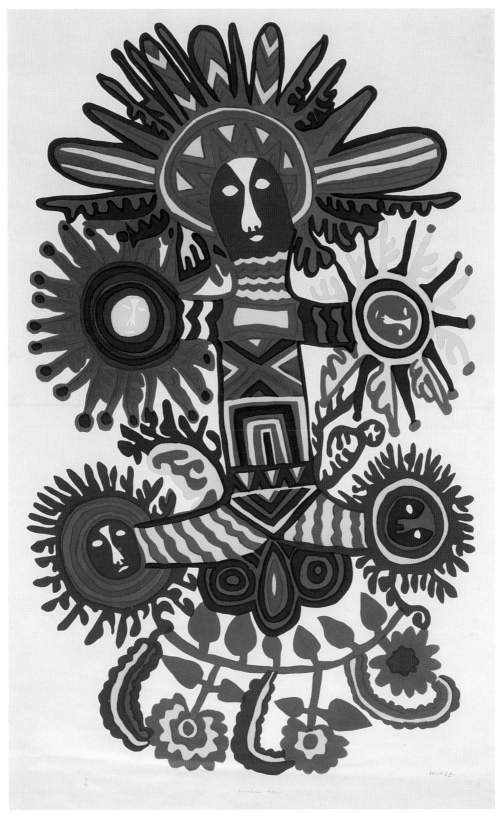

Mathias KAUAGE
Masalai man (Spirit man) 1978 screenprint

In the catalogue for the 1978 exhibition at the National Arts School
in which this work was first shown, it was accompanied by the
following story:

This spirit is wearing men's heads on his bones, and women's heads
which he's decorated with flowers. His skin is really bright and he walks
around at night killing people. When he's eaten them he uses the heads
and bones as decorations.

Mathius Kauage

David Lasisi's book *Searching* (1976)
juxtaposed creative writing with
counterpart screenprints.

David LASISI
The shark 1976 screenprint

The shark

The shark is a dangerous animal
Just the sight of it frightened people
Now let's say a man has died of sorcery
The relatives of the deceased
They will travel to far lands
And pay quite a sum to the medicine man
So the dead man may be avenged.

David Lasisi, *Searching*, 1976

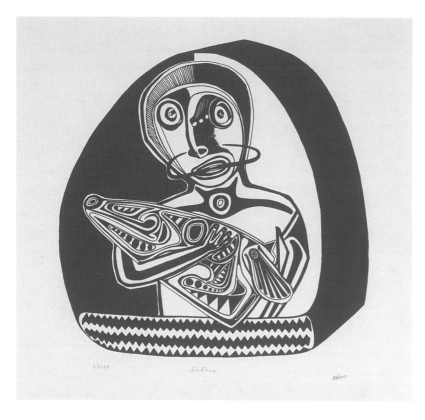

David LASISI
Saben 1976 screenprint

Saben

A certain elder had died
We buried him and then we cried
On a certain night he came back
He was all dressed in black
He stood half-drowned in a water well
And his shoulders he did carry the head
 of a pig

Within this dream Timoth saw the elders
 reappearance
The elder told him that a *Malaggan* must
 be carved
And be put on his grave
Say no more the elder made his
 disappearance
Timoth woke up all confused
And told a wood carver about his dream
Of how the elder had reappeared to him
 and made his request.

Daivd Lasisi, *Searching*, 1976

David LASISI
The confused one 1976 screenprint

The confused one

Writing this note to tell you
About us when one was you and me
I realised that I'm the one
Who's the confused one.

I love you till yesterday
But I hold grudges on you today
Please I can express my love none
Because I'm the confused one.

Oh! Yeah and what do you expect
Me to be so truly perfect
To be like you nun
You confused one.

Also your mistake you said
Please remember I'm no saint
But I don't believe in guns
Yes, you're the confused one.

Then forgiveness is asked
I'm like a coconut being husked
My heart weighs like a ton
OK you confused one.

How can I forgive you silly
When you threw it all in lilies
Any forgiveness is still to be none
Because you are the confused one.

You say you are confused
About me and you being refused
By each other
Only I prayed we may be together.

David Lasisi, *Searching* (1976)

David LASISI
Samkuila 1976 screenprint

This is the origin of my clan which is the
Hawk moiety. Once there was a great
man who gave a fish to our female
ancestor who knows he might have done
this for romantic reasons. So the fish can
be seen in the river which is in the
Samkuila clan's land.

David Lasisi

30/107

David LASISI
The whore 1976 screenprint

The whore

Standing there in the hallway
Ready to take them all
Why not?
She is a whore.

David Lasisi, *Searching*, 1976

Jakupa AKO
Face c.1980 screenprint

Cecil King WUNGI
Untitled 1980 screenprint

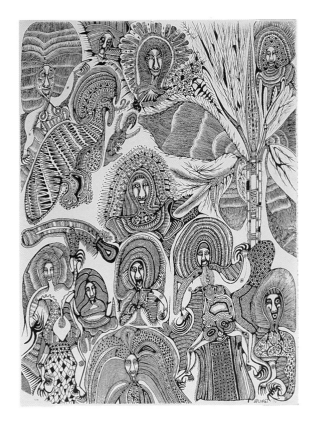

Cecil King WUNGI
Untitled c.1978 screenprint

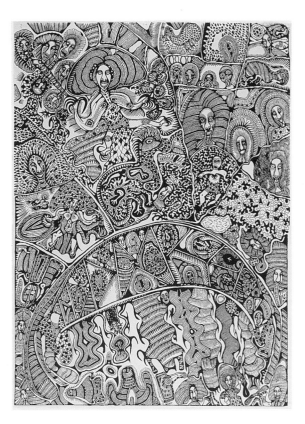

Cecil King WUNGI
Untitled c.1981 screenprint

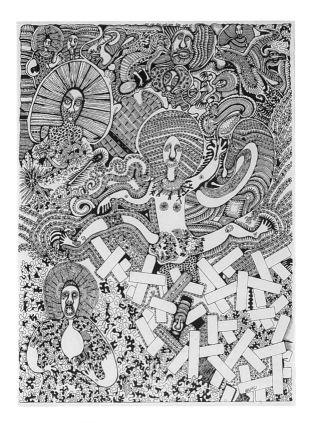

Cecil King WUNGI
Untitled c.1981 screenprint

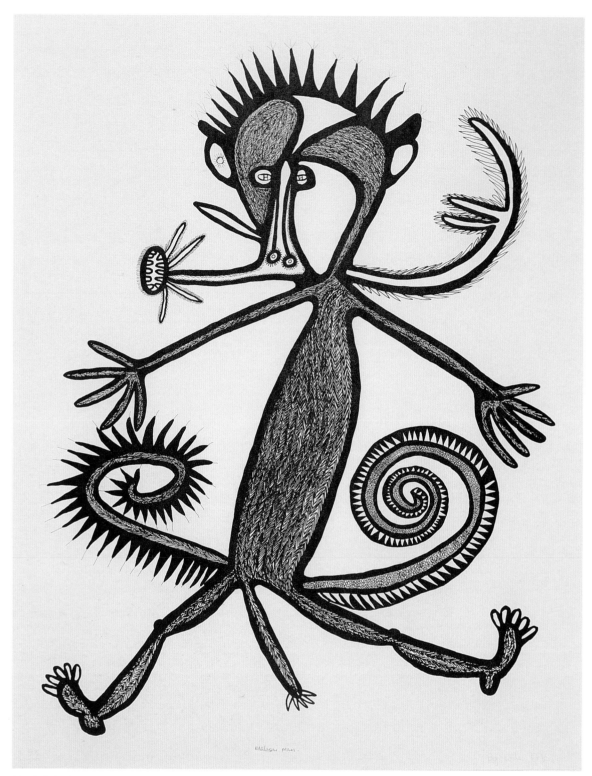

(Timothy) AKIS
Masalai man (Spirit man) 1977 screenprint

Also known as *Man I no laik marit, ol i posen long him* (This man didn't want to get married so they poisoned him). In the catalogue for the 1977 exhibition at the National Art School in which this work was first shown, it is accompanied by the following story:

This man was walking along the road and lots of girls were asking to marry him, but he didn't want to. He didn't like the idea of working in the garden and making fences and things like that. So they poisoned him and really messed up his face. His nose was broken and his mouth was all stretched out of place. Smoke and fire burned his face. He broke out in sores and snakes came out of two of the sores, and his penis was covered in blood.

(Timothy) AKIS
Tupela man [Two men]
1977 screenprint

Man i sanap na narapela man i sanap insait long em. Man i gat hat na lip bilong yam i.

One man is standing inside another man who is wearing a hat and a yam.

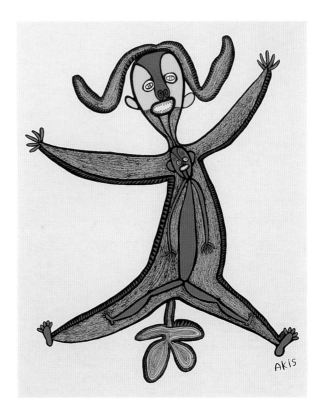

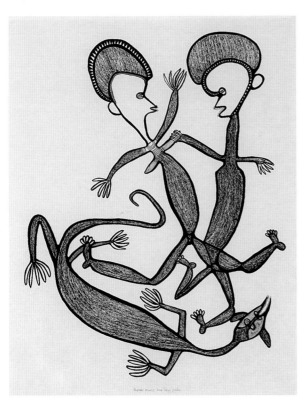

(Timothy) AKIS
Tupela marit kros long palai (A married couple fighting, with a lizard) 1977 screenprint

Also known as *Tupela kros* (A couple fighting). A man was sleeping when his wife lay down and stretched her leg over his body. He woke up angrily and grabbed her.

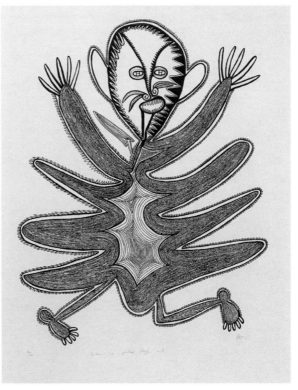

(Timothy) AKIS
Sikin i pulap long nil (Skin full of thorns)
1977 screenprint

Man i sanap na sikin bilong em i gat planti ol nil i stap. Ol nil bilong diwai samting.

A man standing with his skin full of thorns. The thorns are from trees.

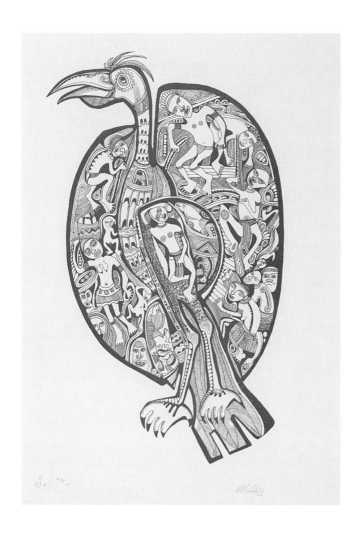

Martin MORUBUBUNA
Boi c.1983 screenprint

Martin MORUBUBUNA
Untitled (Flying insect) c.1976 screenprint

Many people will be aware that the last two decades have witnessed an extraordinary renaissance of Maori culture in New Zealand — a country that is increasingly defined as Aotearoa New Zealand, as a bicultural polity in which there is supposed to be some kind of parity between the traditions and values of the Pakeha, the white settlers, and those of the people of the land. Although, like any other political and social process, this has involved many changes in many arenas and has been brought about through activism around land, legal battles and efforts to reform policy in many areas, art has been peculiarly central to the reaffirmation of Maori culture. The *Te Maori* exhibition of the 1980s is continually cited as an event or series of events that displayed the prestige and power of traditional Maori art, and that compelled recognition of the strength and value of Maori tradition in a broader way. What was vital was not the sheer quality of the pieces, but the fact that Maori ritual was part of their presentation. Their context within a living culture was emphasised, the traditional values were empowered by that context and empowered it in turn.

Maori imagery, that had long been casually appropriated by the New Zealand tourist industry and used in virtually any context where national icons were required, was reappropriated by Maori themselves and affirmed as a set of emblems that expressed the spirituality and vigour of Maori people. Although modernist Maori art had been around well before *Te Maori* and the exhibition itself marginalised non-traditional work, the new climate was one that encouraged contemporary practice in many ways. If there has been a good deal of work that has exhibited cultural roots and traditions in a fairly self-conscious way, the energy, diversity and sheer abundance of contemporary Maori art is arresting. The efflorescence indeed raises the question of how and why visual art, cultural distinctiveness and the political process of cultural affirmation have come to be so closely connected

in this place and time. This is a question about the work that art does in the broader cultural domain; I try to address it here, not through further discussion of the development of contemporary Maori art, but with reference to the work of migrant Polynesian artists in Aotearoa and specifically to a few who are well-known for their prints.

Migrants from Samoa, Tonga, the Cook Islands and Niue moved to New Zealand's cities, and Auckland in particular, in the decades of economic growth and labour shortage after World War II. They came to form substantial communities, but it was not until the late 1980s that they had much cultural visibility in New Zealand. The reaffirmation of Polynesian migrant culture thus followed the reaffirmation of Maori culture, but the relationship has been a rather singular one: Polynesian migrants are not, of course, the indigenous people of New Zealand, though there are many broad affinities between their cultures and those of Maori.

Fatu Feu'u is a senior figure among the Polynesian artists. When I met him first, in 1993, I was struck by the fact that he emphasised he had been initially prompted to express his cultural distinctiveness through art not by members of his own community, or for that matter by Maori artists, but by white friends such as the painter Tony Fomison. Feu'u was, on his own account, then a 'Sunday painter' who emulated Gauguin and Picasso. Encouraged to develop a style that drew instead on his own cultural background, he can be seen to have seized on the idea of a modern Polynesian art, an art that was instantly recognisable for its Polynesian-ness, that he has elaborated and disseminated with great consistency and energy.

Feu'u initially produced a number of paintings that rather deliberately provided a sort of collective narrative for New Zealand's Polynesians. Roger Green, an eminent archaeologist

of the Pacific at the University of Auckland, drew Feu'u's attention to the Lapita pottery traditions of his Polynesian ancestors; the archaeological traditions had enabled this population's prehistoric movements from western Oceania into the central Pacific to be traced. These motifs were therefore part of the common heritage of Polynesian peoples rather than a visual tradition specific to one island or another. In several paintings, Feu'u displayed a flow of these motifs moving across the ocean with migrating tuna, past coastal profiles that Aucklanders would recognise — the dormant volcano of Rangitoto, which ships arriving from the islands passed, and the heads around Manukau harbour, the site of the airport. In other words the ancestral migrations of the Polynesians were linked with their more recent movements; Auckland was identified as only the latest Polynesian landfall in a succession of Oceanic voyages. Some later prints preserved the reference to the Manukau harbour as a kind of gateway for Pacific culture in New Zealand, but Feu'u generally moved away from this perhaps overly deliberate effort to legitimise a Polynesian collectivity in Aotearoa, and instead emphasised, through many works, the strength and power of Polynesian forms. He has tended to rework and develop the same core motifs, based on masks, Lapita pottery forms, tapa and frangipani, which imply a balance of male and female cultural attributes, and he has also consistently situated these motifs environmentally, in the ocean and in the bodies of fish. His work avoids the contentious domain of New Zealand ethnic politics, but has continually called for the preservation of the Pacific environment and, specifically, the preservation of its fish stocks for future generations.

To suggest that in New Zealand, even more than elsewhere, this is not a stance that will meet with much opposition, is to miss the point; it would also be missing the point to suggest that Feu'u's very extensive corpus of prints in the end reduces the Polynesian motifs he parades to a decorative art. If he indeed seems to have single-handedly invented and exhausted an art movement, its lapse has been a failure specific to success. Feu'u has not only been a prolific printmaker and painter but his images have also been printed on cards, shirts and book covers; they have been transposed onto rugs, glassware, furniture and pottery, and they have inspired, if not been directly acknowledged in, much design in printed material, fashion and interior decoration. What Feu'u has done, in other words, is to create a Pacific visual idiom for which there has clearly been great demand.

Although Feu'u was certainly the first, and has remained the most energetic, the contemporary Polynesian cultural movement in Aotearoa has proliferated very rapidly, and there are now a bewildering range of talented and innovative musicians, writers, photographers and fashion designers, as well as artists, who have given this neo-Polynesian culture new diversity. Like Feu'u, Michel Tuffery, primarily of Samoan descent, is supposed to have begun by emulating European artists until prompted by his art teacher to make his Polynesian background show in his work. Like Feu'u also, he took the idea and ran with it, inventing Pacific forms of his own that were highly distinctive and visible. For the most part, neither artist has sought to narrate specific myths or histories through art, nor has the imagery generally referred to very specific aspects of Polynesian tradition or geography. It has been an evocative art that has created polysemic Oceanic forms and symbols; the motifs suggest cultural richness and spiritual dynamism, but they are accessible rather than culturally particular or esoteric. They inaugurate a Polynesian sensibility that belongs not so much to the specific cultures in the islands of tropical Polynesia but to New Zealand cities, in which an emerging culture demands an aesthetic and an identity that departs from the stereotypic and conservative anglophilia for which New Zealand was long notorious, and that instead inscribes the place firmly in the Pacific. The reason why this new visual culture should make such space for Polynesian, rather than Maori artists, is a point I will take up later.

Tuffery's work has, like Feu'u's, acquired much broad visibility. This was especially conspicuous in Wellington a couple of years ago during the international arts festival, which had shifted from being a more generally cosmopolitan event to one that combined a range of international concerts and shows with great emphasis on contemporary Pacific culture. In 1994 Tuffery was commissioned

to do the posters, the banners, even the design for a fully-painted bus; his iconography was, in other words, for a short period seen everywhere around town.

The specificity of this kind of art can be underlined through contrast with the prints of one of New Zealand's finest living artists, Ralph Hotere, who is of Maori descent but has generally avoided being defined as a 'Maori artist'. Though best known as a painter, and latterly as an installation artist, he has produced many fine lithographs, which are generally abstruse, allusive and meditative, though sometimes also politically pointed and angry. It is highly personal, yet it often also explores both very global and very local issues, ranging from the Gulf War to environmental issues around southern New Zealand, and particularly the aluminium and harbour developments that have directly impinged on Hotere's own environment. What his work has never done is produce collective symbols, or emblems, that stand for a culture or a people. Many of the predicaments he refers to — of mortality and loss — are those of humanity in general, and many of his political causes are those that impinge directly or indirectly on others. But this is not an art about shared culture, nor an art about identity. The status of Hotere's work is acknowledged in all kinds of ways by New Zealand curators and others, but it will never have the particular public use that Feu'u's for instance does. It may sustain some people in New Zealand in certain spiritual and intellectual ways that are hard to define; it does not help them as New Zealanders preoccupied with the redefinition of their identities.

Some Polynesian artists could be seen to be in an intermediate position, between the representation of a collective identity and the almost deliberate disavowal of any such project, on the part of Hotere. John Pule's work mobilises a dynamic personal iconography that is loosely inspired by Niuean barkcloth — at least by the combination of inventive freehand forms within grids and figurative elements. Yet Pule is inspired as much by estrangement from Niuean culture as by his origins in it. In particular, he rejects the authoritarianism and the suppression of shamanic mythology which came with the Christianity that Niue, like the rest of modern Polynesia, embraced.

His work therefore speaks an eroticised transgression, a personal history, a sense of place, and an overtly imaginative mythography.

Pule's work has not been as widely reproduced through commercial media as Feu'u's and Tuffery's. This level of dissemination is in fact something he has avoided, but his paintings and prints have nevertheless acquired a certain public presence outside art galleries, not least through conspicuous display in a major Auckland harbourside restaurant. Their visibility is part of a much wider wave of Pacific fashion that is conspicuous in youth culture in music and clothing — in tapa prints and actual tapa grafted onto denim, for instance — and in other forms for other audiences.

The question arises of quite why this Pacific accent should have become so attractive to New Zealanders. I suggest that it represents an extension of the effort to localise a white New Zealand culture which has long proceeded via the adaptation — or the appropriation, if we are to use a language of cultural property — of Maori motifs and Maori art. One of the effects of the cultural and political shake-up that followed from *Te Maori*, however, is a strong moral sense that Pakeha New Zealanders can no longer so liberally reproduce and disseminate adaptations of Maori forms that in many cases were transparently vulgarised. The affirmation of Maori culture has entailed great emphasis upon the sanctity and spirituality of many Maori art forms.

Cloth printed at the Pacific Resource Centre Youth Workshop, Wellington, New Zealand 1997

The reproduction of these forms has thus become a profoundly politicised business and it is one that Pakeha have come to shy away from. Although many art historians and art critics came to the defence of the modernist abstractionist Gordon Walters, whose work from the 1950s drew consistently on Maori forms, one of their chief arguments was that this borrowing had a value at that time different to what it would possess now. It is notable that few contemporary Pakeha artists even attempt to work from Maori forms, except occasionally in a deliberate effort to provoke contention.

Settler–indigenous relations are singularly agonistic because they revolve around the question of dispossession and the usurpation of power. Dispossession is not a one-off event but a process that seems to be reiterated and contested again and again, in many different domains ranging from the control of land itself to the control of language and representation. The business of the reproduction of Maori motifs is a fraught one because it recapitulates this fundamental contradiction of the settler–colonial polity. Despite the colonisation of the Pacific Islands by Europeans, the history of those relationships is not dominated by this binary antagonism, or/by this enduring negative reciprocity. The question of cultural exchange is not fraught to the same degree. Although Polynesians may certainly be disturbed by particular adaptations or commercialisations of their art forms, the issue is not embedded in a fundamental and enduring contest over land and sovereignty. The dissemination of tapa motifs and related forms may be more or less contentious from time to time, but it will never be contentious in the same way that the reproduction of, say, Maori *koru* motifs [Maori spiral designs] has been. The appeal of Pacific iconography, then, derives from the fact that it provides a new New Zealand, an Aotearoa New Zealand, with a visual culture that belongs to Oceania. On the one hand, it is possible to leave behind a European heritage that seems to have lost its relevance; on the other hand, these Pacific Islands traditions can be embraced, without seeming to extend or reproduce the process of colonisation. Like all solutions to cultural predicaments, the Pacific accent must surely, however,

be seen as a provisional rather than a final resolution of the problem of New Zealand's identity, if that does amount to a 'problem' that requires a 'solution'. Those engaging in cultural exchange tend always to receive both less and more than they bargain for.

Nicholas Thomas

This paper was first presented at the Third Australian Print Symposium, National Gallery of Australia, 1997

Paratene MATCHITT
Taumatakahawai from the folio *New Zealand 1990* lithograph

Robyn KAHUKIWA
Waitangi from the folio *New Zealand 1990* 1990 lithograph

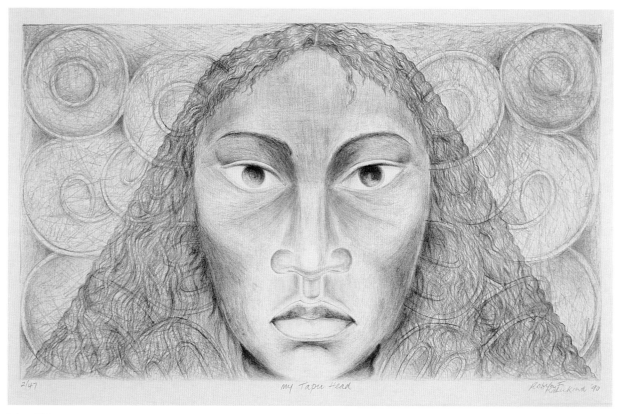

Robyn KAHUKIWA
My Tapu head 1990 lithograph

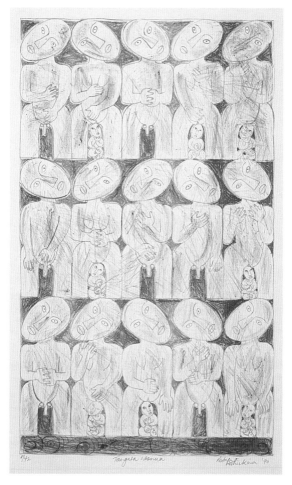

Robyn KAHUKIWA
Tangata Whenua 1990 lithograph

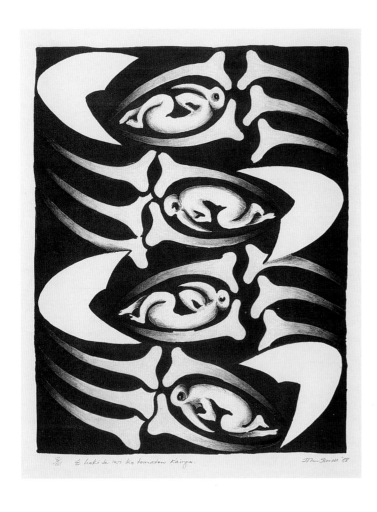

John HOVELL
E hoki te iwi ko tomatau Kainga 1988 lithograph

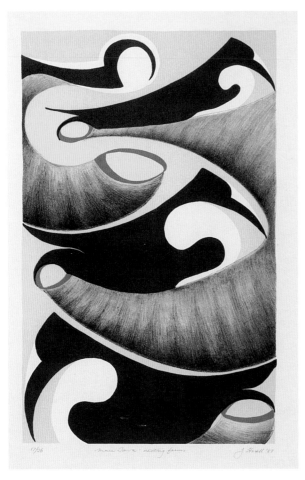

John HOVELL
Manu tava: nesting forms 1987 lithograph

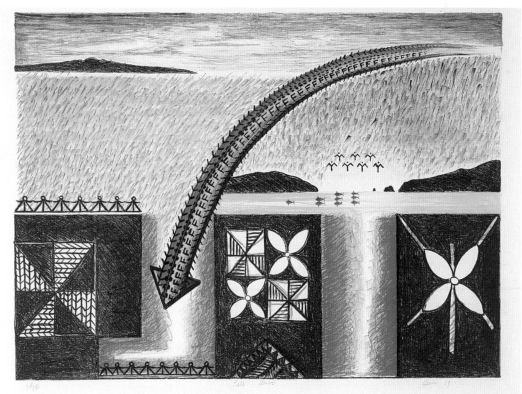

Fatu FEU'U
Pale auro 1989 lithograph

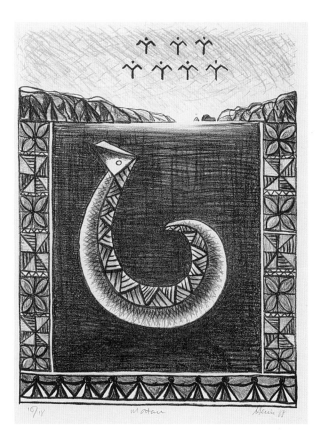

Fatu FEU'U
Matau 1988 lithograph

I feel there is so much art to be made, so much
to be said about being a Samoan New Zealander,
so much to say to my children, my mother, the politicians.
I paint about the issues that are important to me, anger,
love, the land, conservation and our culture, my children.

Fatu Feu'u

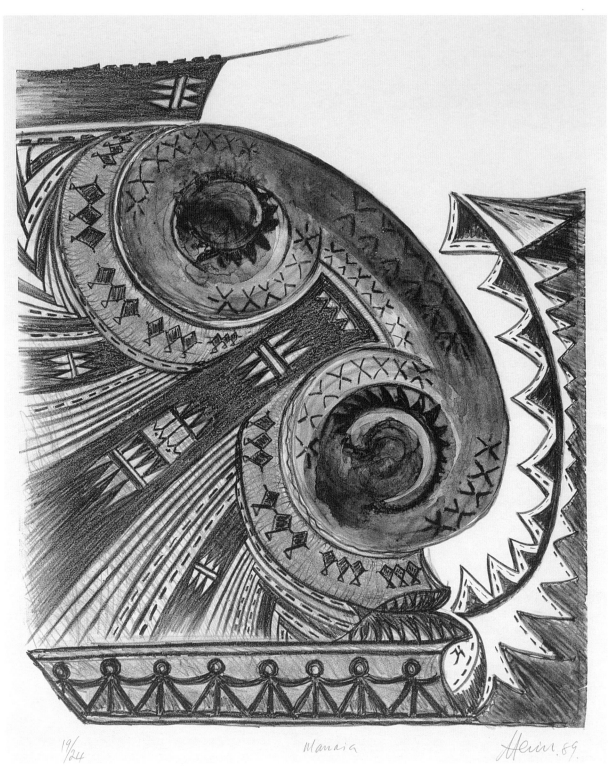

19/24 Manaia Heim.89.

Fatu FEU'U
Manaia 1989 lithograph

Fatu FEU'U
Alo alo 1990 lithograph

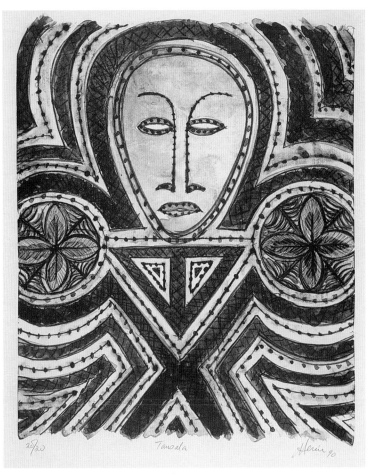

Fatu FEU'U
Tausala 1990 lithograph

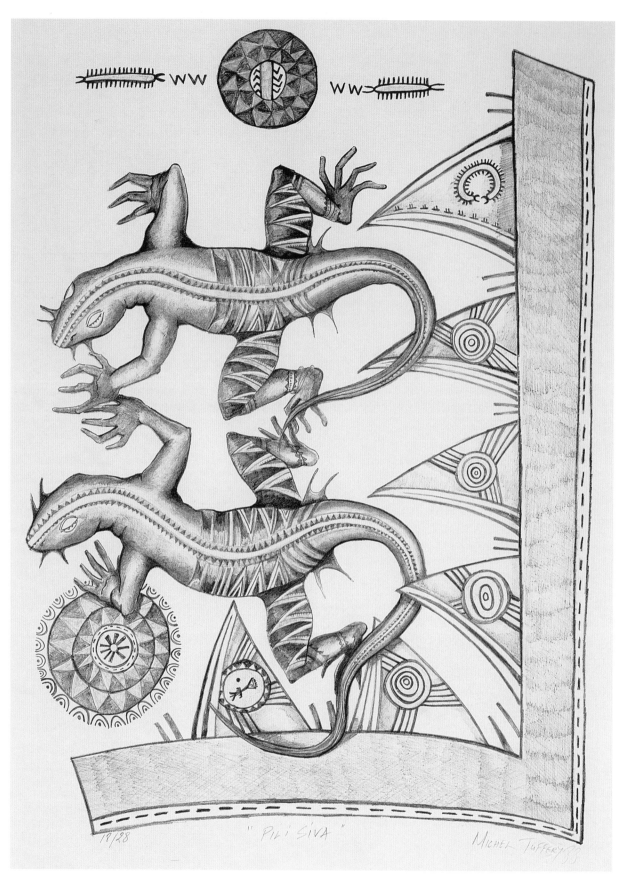

Michel TUFFERY
Pili Siva 1988 lithograph

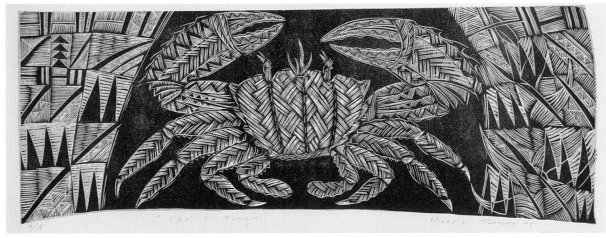

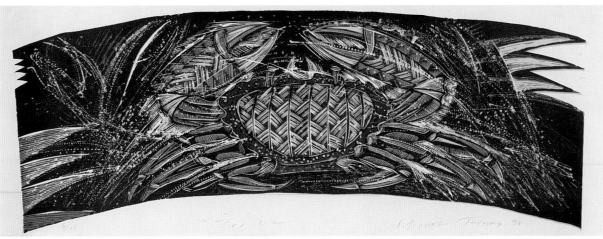

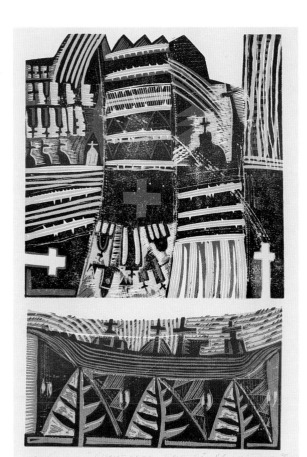

Michel TUFFERY
Pa'a e Tonga 1998 woodcut

Pa'a e Tonga is a study from observing the crabs in the mangroves around Cairns. Michel printed it in Cairns, where he ran a series of printmaking workshops for the Tropical North Queensland Institute of TAFE and the wider community.

Michel TUFFERY
Pa'a Lua 1998 woodcut

Michel TUFFERY
Christ Keke Fala Sa 1998 woodcut

Christ Keke Fala Sa is somewhat of a reaction to an artist-in-residence term Michel had just completed in Christchurch before travelling to Cairns to undertake another residency. Christchurch is a very English-styled city and is known for the number of churches it has. The print is a broad-scaled view from our apartment.

Jayne Tuffery

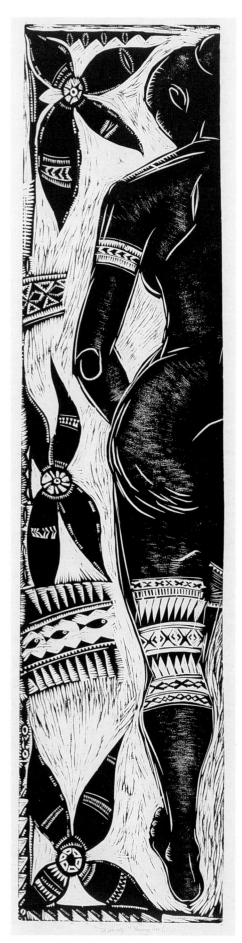

Patrice KAIKILEKOFE
Ta'ahine (Young girl) 2000 woodcut

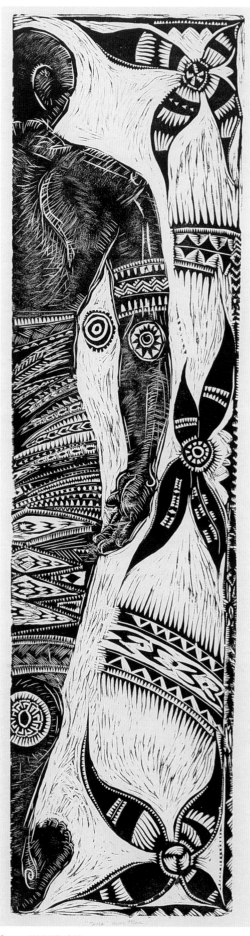

Patrice KAIKILEKOFE
Tama (Young man) 2000 woodcut

84

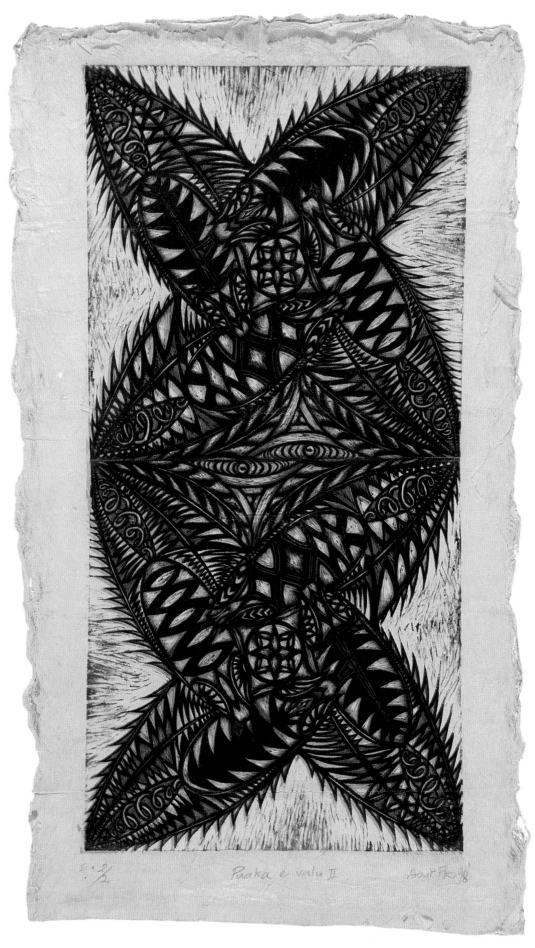

Patrice KAIKILEKOFE
Puaka e Valu II 1998 woodblock

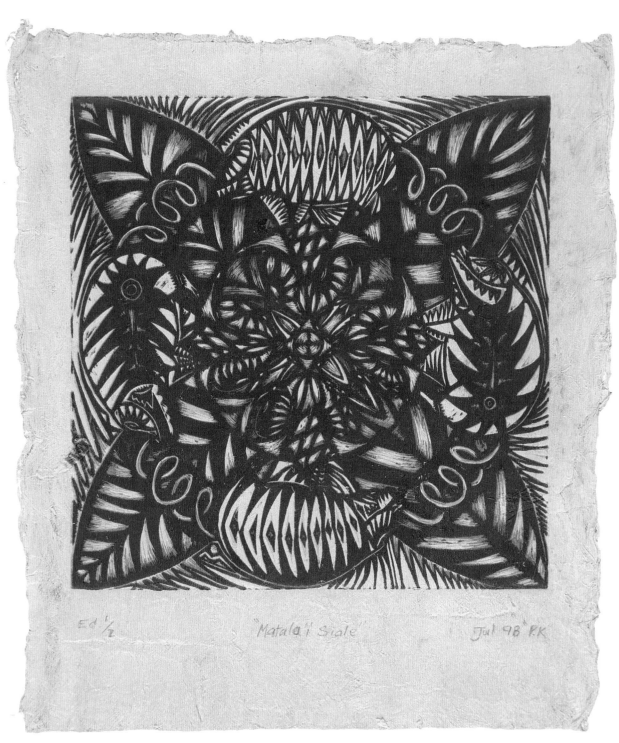

Ed ¹/₂ "Matala'i Siale" Jul 98 P.K

Patrice KAIKILEKOFE
Matala i Siale 1998 woodcut

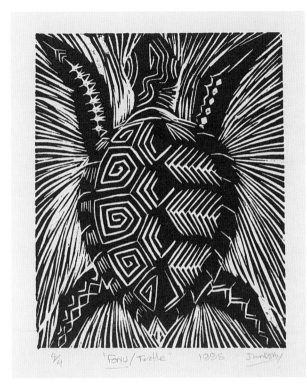

Joe LINDSAY (SALE)
Fonu / Turtle 1995 woodcut

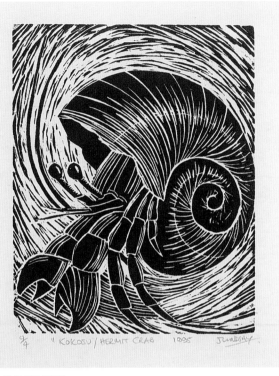

Joe LINDSAY (SALE)
Kokosu / Hermit crab 1995 woodcut

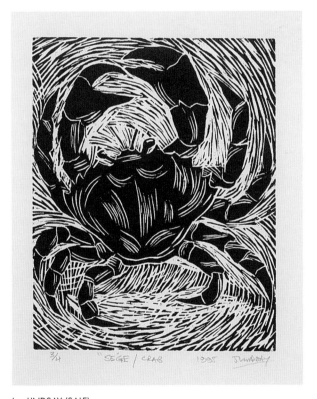

Joe LINDSAY (SALE)
Se'ge / Crab 1995 woodcut

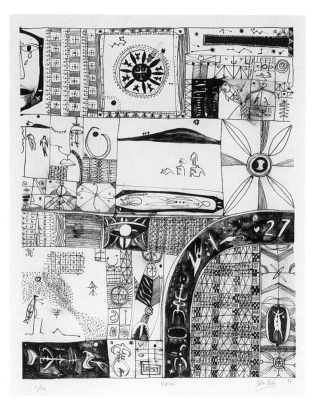

John PULE
Pokia (Together) 1995 lithograph

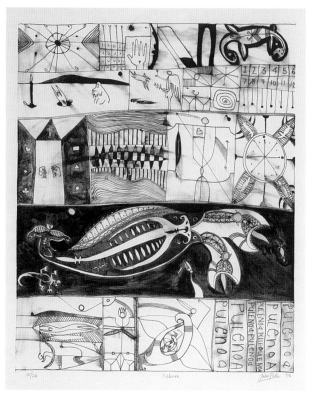

John PULE
Pulenoa (Without consent) 1995
lithograph

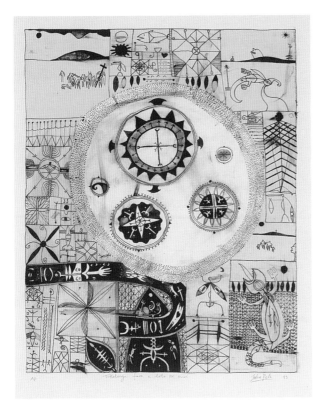

John PULE
Tokolonga e faoa in loto ne misi (Many people in a dream)
1995 lithograph

The composition of John Pule's prints is based loosely on the
Niuean *hiapo* (tapa cloth), but explores a more personal iconography.
He incorporates genealogies, journeys, stories and histories;
mythological creatures, birds, monsters and symbols also find their
way into his work.

When you look down on to the tapa, the patterns look like a plan
of a village, or a plan of tracks going down to the ocean. I have also
seen photos of old Niuean tapa, decorated with big circles, and
painted in these circles were twigs and branches and leaves. I think
of the circles, and what was contained inside as a kind of philosophy,
based on wholeness. The circle contains the balance and harmony
of a person's life, and if you do anything wrong then that circles is
going to bust.

John Pule

UNFAMILIAR TERRITORY: AN ART OF CONSTANT TRANSLATION

What do I assume about artists and the way they work? What do I assume when I look at the product of that work? Even though I act within a world view based on the instantaneous flow of ideas, images and knowledge around the globe, I still assume that works of art are the products of unique, gifted, inspired individuals, expressing their particular experiences, understandings and insights. Yet when the work is derived from a different framework of cultural practices, or as the result of a deliberate collaborative strategy, I am provocatively disoriented. More than one mind, more than one creative sensibility, more than one cultural context, and most of my assumptions of value are destabilised. No longer is the work seen as a 'portal into the subconscious', born of isolation, the ideal of physical and emotional sensation combined. These are stereotypically the key values we are trained to look for in a work of art.

In this essay I have chosen to write about some recent works which sit outside this canon, which through their collaborative processes produce quite different kinds of ideas, images, knowledge and values.

From *New Angel* to *Cakacakavata*

The work of New Zealand artist Robin White has for many years derived its subject matter, forms and sensibilities from the experiences of her life in the Central Pacific nation of Kiribati. Over the last few years she has begun the process of working with other indigenous people, initially through designing and commissioning works to be realised by others in the indigenous media and crafts practices of weaving and embroidery. However the most recent tapa project *Cakacakavata* is of a different order, more comprehensively collaborative, and as a consequence all the more challenging in its possibilities for interpretation.

This collaborative way of working began in 1997 with the embroidered needlework tablecloth made by Florence Masipei and with the *New Angel* series of woven pandanus mats produced with the assistance of Nei Katimira at Teitoiningaina, the Catholic Women's Training Centre. The imagery was derived from a series of drawings made during a residency in Canberra, later developed as watercolours and exhibited together there at Helen Maxwell's gallery in November 1998.

The initiative for finding new methods and materials occurred through a displacement of an altogether different and dramatic kind. After her house and studio in Kiribati burnt down in 1996, Robin found herself with only rudimentary materials to work with — A4 paper, crayons, felt pens, scissors and glue. At this point she began to make drawings for woven pandanus mats, with imagery derived from the work produced in Canberra. She conceived the idea conscious of the colourful and innovative mats produced in Tuvalu, in which they weave the substructure of the mat and then insert the coloured elements. This is a style adopted by the I-Kiribati weavers which they call *Te Wanin* — described by textiles artists in Australia as a warp and weft overlay.

The circumstance and methods of production of the 'placemats' which involved working with weavers and, simultaneously, the production of the embroidered tablecloth made possible with the expertise of her close friend Florence, was for Robin a crucial preliminary experience for the *Cakacakavata* tapa works produced two years later.

The apparently mundane nature of the placemats and tablecloth is deceptive. The Baha'i Faith, of which Robin is a member, instils a deep motivation to produce work which symbolically represents the potential of world peace and the reconciliation of conflict. Thus while the history of art is full of representations of tables and meals

as symbolic subjects (and reference to the Last Supper is no coincidence in Robin White's motivation), in this instance the table as a site of conviviality and social interaction carries powerful affirmative values. The title of the series, *New Angel* (the name of a brand of tinned mackerel) and the other representations of food, drink and tobacco create an equivalent context for daily life on Kiribati. The 'new' of *New Angel* also affirmed for Robin the potential for change and renewal in matters of identity and belief.

The mats are woven from pandanus leaves, a sacred material in the culture of the I-Kiribati. Pandanus is believed to provide a totemic key to their origins and the history of occupation of the islands. Like food and tables, the material itself has both mundane and sacred connotations. With these ideas for a collaboration in mind, Robin first approached an I-Kiribati friend who advised her to make a drawing of what she wanted. For this she devised a diagonal grid, enlarged and photocopied it, and then produced the six gridded drawings, in their full coloured complex version. Robin then worked from the full colour images to a second more monochromatic

version, and finally to a third set, the most simplified version of each of the six images.

The three 'sets' differ insofar as the image appears (if looked at in reverse order of simplification) to be a kind of distillation of the iconic value of the image — stripping the original images (full colour) of their easy equivalence to their origins in commercial art and working back towards their graphically most reduced elements.

Suspecting that this would be too much for any one woman to carry out, Robin visited a group of women involved in an I-Kiribati women's organisation based in Bikenbau, near to where Robin lived, and discussed with them the possibility of weaving the mats from the gridded drawings. She showed the I-Kiribati women one of these 'set 2' images (*Instant sunshine*) and, to Robin's surprise, the women pronounced it 'unfinished' and 'incomplete' — which Robin later realised was a consequence of its asymmetry, given that all traditional Kiribati mat patterns are symmetrical. She took this to be a signal of their insecurity about the project and decided to approach the Teitoiningaina ('The Day Star'), the Catholic Women's Training Centre in the

Robin White *New Angel* 1998 woven pandanas

91

village of Teaoraereke. With all the sets of drawings complete, she went to see Nei Aroita and Nei Katimira at the Centre. Nei Katimira was already known to Robin as a very accomplished weaver. She was in charge of the handicrafts program run by the Centre, which had three organised groups of women at any one time undertaking training in catering, sewing, and handicrafts. These women already had the advantage of an infrastructure capable of carrying out the project Robin proposed. Katimira was enthusiastic and said they could do it, immediately seeing its possibilities for the women at the Centre. So the gridded plans were laminated and left with Katimira and the work began under her direction.[1]

The process for the production of the tablecloth *Food for thought* was less complex, through Robin's existing friendship with Florence Masepei, a highly accomplished embroiderer. Embroidery is a form of women's craft with its roots in missionary training. Embroidery is now used by many women for the elaborate decoration of *lava-lava*, a rectangular cloth worn like a kilt or skirt, characteristically depicting floral emblems and the wearer's name. Florence worked from Robin's watercolours and her interpretations of the motifs reveal a much greater degree of freedom in her capacity to interpret the original imagery.

As might be expected from the nature of the commissioning process, in both the *New Angel* mats and *Food for thought*, the imagery derives from Robin White's previous work in both style and content. Curiously, even the isometric micro-structure of the images strikes a continuity with her earlier prints, paintings and drawings, both through her consistent conjunctions of image and text, of image and landscape, and through the sense of graphic devices which suggest spatial compression. This, with the deliberately questioning relation between text, translations and motifs derived from popular commercial culture, are all characteristics of her work over an extended period of time. The spatially compressed simplification of the imagery, the deadpan irony of trademarks which resonate with echoes of the ready-made, and the ready-made's capacity to suggest a disjunction between cultural and economic contexts gives these works

their incisiveness — at once quietly reflective and pointedly analytical. This suggests that the artist has chosen images and conjunctions which, through her own artistic heritage, evoke the particularity of her own time and place and her ambiguous status as insider and outsider at the same time.

The nature of this collaboration differs greatly from the *Cakacakavata* project. *Cakacakavata* (called *masi* in Fiji) means 'working together'. In this case it has a profoundly symbolic value for the two artists and, through its subject matter, the references to food are similarly loaded.

The tapa of the *Cakacakavata* project were made with Leba Toki from the village of Nasau Moce Island, in the Lau Group in Fiji. Leba describes the collaborative process in relation to the importance of consultation — which they both derive from their common Baha'i beliefs. They speak about a higher motivation for working together: to demonstrate the possibility of collaboration as a symbolic process embodying hope and optimism for a peaceful and harmonious world. As the project developed, both came to recognise the complexities of their differences, and the way in which the work inhabits a space between the conventions of the different worlds they inhabit.

Robin was motivated by the traditional tapa she used to see hanging in the transit lounge at Nadi airport on her many visits to and from Kiribati. She made drawings of the details and she tells how they 'worked on me over a very long time'. In particular, she was stimulated by the contrast with Samoan and Tongan equivalents. Through her Baha'i connections she had visited Leba and knew that she used to make small tapa: 'this is my job, every day, in the village'. For Leba also, tapa is a sign of the outside world, in that it derives from Tonga — the influence of which is strong in the Lau group.[2] In suggesting they work together, both accepted the symbolic dimension of the act of working 'across the threshold' as being 'about people figuring out how to live together', embodying the wider implications related to the universalist beliefs of Baha'i.

Cakacakavata is the outcome of a month's work by Robin and Leba in Robin's house and studio

in Masterton, New Zealand. The themes and titles of the three-part work, *Tea, Milk, Sugar*, (all produce with Fijian associations), while sharing the same mundane associations ('a cuppa tea') as the *New Angel* series which preceded it, were embraced by Leba in recognition of their deeper symbolism (illus. pp.100,101).

In the collaborative process, Robin's influence is clear in the overall structure of the images — derived from flattened out packaging — and the inclusion of minor imagery both related to the *New Angel* series and other icons of Fijian origin, along with other autobiographical sources. Thus we see the inclusion of the kava bowl *tanoa*, fan *ici*, club *viri*, ceramic bowls *saqmoli*, and the Hindu hand gesture, alongside the teapot, cups, spoons, barcode, cow, Matisse's cut-out birds (Robin remembering Matisse in Tahiti in the 30s), and the *moko* from the portrait of Robin's great-grandmother Mere Te Wia painted by Joseph Merrett in 1850 in the Auckland Museum.

For Robin the themes of packaging and popular cultural icons evoke signs of modernity whereas the material qualities and patterning of the tapa relate directly to Leba's traditional experience. Some innovations are very Fijian — such as the inclusion of centipedes which wander around the edge of *Milk* (humorously referring to the consequences of gossip), and yet for Leba the innovation implicit in this kind of image is 'very new to me'.

The autobiographical dimension of these works is something that is also challenged by the process of working collaboratively. Such elements exist in a particular kind of balance, each questioning its origins in the other artist's identity. The viewer is lead to ask: who speaks through which element, through which episode of the process, through which material, process or sign?

In *Sugar*, the image of the Chelsea Sugar factory is one such motif. Albert Tikitu, Robin's father, used to work in the factory when her family lived in Birkenhead on the north shore of Auckland city in the early 1950s — she remembers seeing it on walks along the cliff top — and here again she finds its iconic representation beckoning to her from the packaging she discovers in Fiji.

The packages are much modified in their final form, although still recognisably specific to their origins. These modifications and variations are the record of many decisions, made between the two artists, which occurred at the micro-iconic level. For instance, in *Tea* the original insignia of the lion holding a sword is transformed into a lion holding a Fijian war club. At another scale the viewer becomes aware that whole sections of the original image have been modified, moved around and sometimes replaced by passages of traditional patterning. Thus at one level the work can be understood as a record of its own creation, the implicit narrative between the two artists as their modes of creativity interacted one with the other.

Many traditional aspects of the structure of the tapa are still present and are subject to Leba's initiative and authority. Thus the outside rows of stencils are called *waqani*, the next inner row is *codo*, the next *draudrau ni damu* 'crab pattern', and so on. But the imagery of the cup, the sugar cane and the lion are in the space usually occupied by flowers called *vutu*, and the other icons are called *tutuki* (the lava bowl *tanoa*, fan *ici*, club *viri*, ceramic bowls *saqmoli*, or Matisse's birds). Sometimes these *tutuki* escape the structure and float 'in the night-time area' in the black sections outside the frame created by the structure of the package. Some of the internal devices — like the double black lines around forms — are derived from traditional designs, and sometimes elements such as the cruciform in the *Milk* tapa, began as elaborations of a simple graphic form, which through alternating decisions, in a dialogue between tradition and innovation, arrived at its final resolution.[3]

In its traditional usage, tapa is used for many other purposes: clothing, blankets or, most significantly, rites of passage for birth, death, marriage, and birthdays. For high ranking persons, very long tapas are still produced as ceremonial gifts, sometimes personalised with the individual's name.[4] In discussions about her role, Leba speaks with enthusiasm about future works, tapa of different proportions which correspond to the shape of costumes made for weddings or other events like birthdays and funerals.

Gapu, tubig, air, water

The first Australasian Print Project was held in June 1997 at the Northern Territory University (NTU) in Darwin. The artists participating were Djalu Gurruwiwi and his wife Dhopia Yunupingu from north-east Arnhem Land, Ardiyanto Pranata (Indonesia), Yuan Mor'O Ocampo (the Philippines) and Peter Adsett (Northern Territory).[5] In the choice of artists their hosts consulted advisors with knowledge of artists in the region. They wanted to show how cross-cultural collaboration could be translated into interesting and distinctive art through the artists' commitment to a collaborative process and their experience of new media.[6] Thus the artists were specifically invited on the basis of their receptiveness to the opportunity for cross-cultural experience and influences. Within their own established form of artistic practice (painting, installation, batik), each had achieved a sufficient authority to benefit from the experience of the new set of processes made available through the expertise of the staff of the NTU Print Workshop.

While the facilities of the Workshop and skills of the printers enabled each of the artists to explore unfamiliar territories in significantly new ways, one aspect was immediately significant. Out of their diverse backgrounds, it was their *lack* of expertise with the new media of printmaking which stimulated much interaction around the choice of a common thematic for their work. The chosen theme was the significance of water.

The different cultural backgrounds of Indonesia, the Philippines and that of indigenous and settler Australia were initially subsumed by the artists' relative unfamiliarity with the new media at their disposal. This resulted in a kind of technological displacement which enabled new kinds of experiences and insights into their work. Thus the basis of their differences, their traditions and histories was focused by the theme of the project and the ways in which these artists went about working together, as they responded to the creative uncertainties of the situation presented to them.

For an artist, a new medium is provocative. For these artists it was also an invitation to engage productively with each other's traditions and to accept the challenge to their conventional ways of working. Apart from the levelling effect of dealing with new media, in different ways each artist was also subject to a cultural condition of displacement which, while affirming their own cultural specificity, produced a cross-cultural engagement of an unfamiliar kind.

Collaboration and interaction across cultures might be understood as a response to an idealism motivated by desire for some kind of universal equivalence between creative practices. This has happened so often that it now seems that acting outside one's traditional sphere has itself become a shared cultural tradition, a characteristic of late 19th-century modernity. Individuals act outwardly, oscillating in the stimulating tension between centres and peripheries, home and away, seeking to affirm their particular identity as artists while at the same time reaching outwards towards new international contexts.

In one sense, it is no surprise that this project should arise as an initiative of a printmaking centre: the practice of printmaking itself epitomises the collaborative process through its long tradition of creative interaction between artists, printers and technicians. While the print is often an end in itself, print technology also enables the translation of imagery from one medium to another, and is therefore compatible with the processes of cultural translation which take place through such events.

With this project, such factors combined to produce a non-hierarchical set of relationships between the artists and an openness to exchange. Despite different backgrounds and varying authority and experience within their previous practice, each was a relative novice at the media at their disposal. This led to a mutual interest in each other's learning processes, where exchange at the level of technique opened the way to exchange at the level of meaning, through the translation of the processes, habits and conventions each participant brought with them. This was facilitated through the discussions which lead the artists to adopt the common theme of water as the guiding topic of their individual works.

In the sophisticated cosmopolitan art world in which three of the participants (and the three printers) practise, other artists' frames of reference tend to be taken for granted, silently assimilated, and cautiously probed through questions and comments. By contrast, the Yolngu artists Djalu and Dhopia proceeded from a completely different set of assumptions, where the equivalent of such knowledge is gained not through interrogation, but through revelation. As Djalu explained:

> … how meaning comes in. That meaning comes closer, see, little bit closer, when I go and get in, for thought. Because I got thought, but different fraction, like a compass, or something like that, see? When I experience, I can see, learning that way, because different religion, different different background, different languages, different thinking.

This reflects a crucial cultural difference around which a great deal of the deeper interaction took place between the participants. The non-indigenous artists and printers were all acutely aware of the position of cultural priority which existed for the indigenous artists. For the non-indigenous artists, there was an acknowledgement that an indigenous artist may assume an intimate relation to place and land, as when travellers search out and recognise the authority of those who own the land through which they pass. As a consequence of this deference to the Yolngu artists (even though the workshop took place on Larrakia land) the potential for a collaborative collective work began to be recognised as a latent possibility as the project proceeded.

The non-indigenous participants also became aware that the informal connections which developed in the context of the quiet intensity of the studio were by necessity being directed towards a quite different level of relationship by the indigenous artists. For the Yolngu, the world does not make sense until its significant elements are properly placed within an appropriate kinship system. So for the Yolngu it was necessary for each of the participants to be located in kinship terms, through which each may find their proper mode of interaction with the other, and recognise appropriate responsibilities in the conduct of their affairs.

Thus early in the project each person discovered how they had been placed within a kinship system which allowed them particular kinds of relationship and activity. This opened the way to a kind of cultural exchange (and thus the potential for more meaningful interaction) which was outside the experience of most of the participants. In the last few days of the project, when the opportunity presented itself for a collaborative work, little encouragement was needed from the printers for the artists to produce the screenprint Gapu, tubig, air, water (illus. pp.103–105).

In determining the structure of the print, the Indonesian artist Ardiyanto drew on his intimate knowledge of his own indigenous culture of fabric art to devise a non-hierarchical architecture within which each of the five artists could contribute to the overall schema. Perhaps unwittingly, but perhaps also as a spontaneous outcome of the synchronicity of this event, this pictorial structure provides profoundly symbolic dimensions to the work. The structure of Gapu, tubig, air, water serves to highlight the central image by the senior Yolngu artist Djalu and, in the process of developing the images which frame it, the other artists have implicitly paid homage to his authority and to the Aboriginal participation in the project.

This particular structure and combination of imagery also evokes deep associations between the pictorial conventions of north-east Arnhem Land, as well as ancient cultural connections between the Yolngu and visitors from the Indonesian archipelago which evolved over many centuries of harmonious cultural exchange. Contemporary bark paintings from this region still echo these pictorial conventions, allowing different people and different groups to combine in the production of similarly complex visual imagery to mark significant cultural events. For instance, the great Yirrkala church panels (which stand as the originating icons of the struggle for Aboriginal Land Rights and are now in the Buku Larrnggay Mulka Museum) evoke the same conventional framework as this print.

Both in the choice of medium and in the sequential process used to produce this image,

the non-indigenous artists of this project also deferred to the colours, sequence and screenprint process with which the Yolngu artists were most at ease. By the time the artists had combined to work on this print, each was well aware of their adopted kin relationship and responded accordingly. Thus Mor'O consulted his *ngarndi* (mother) Dhopia on the form, colours and structure of his section, according to the totemic references to quail and crocodile eggs to which he could refer through kinship association.

As Djalu's classificatory father, Ardiyanto chose to paint his section in a manner which stressed his own traditional cultural roots in batik and, by inference, the wider cultural ties within the region. Peter Adsett's section refers to his discussion with Djalu about *djäri*, the coloured surface of the *riyala*, the stream which flows between the two waterholes where he lives at Humpty Doo, together with references to the waterlily leaves Djalu had seen there.

Dhopia completed the cycle by painting her own Yirritja moiety motif of *larrakitj*, the hollow log coffin with *djirrikitj*, the quail who lay their *mapu* (eggs), inside, and *wan'kurra*, the bandicoot, who is looking for *ngatha* (food). Djalu's central image is a part of the story of Bol'ngu, the thunderman, who sends down *djambuwal* (the waterspout), which creates a freshwater waterhole in the middle of the ocean. Other elements of this image are reflections of his earlier paintings of the subject (see for example the painting *Bol'ngu, The Thunderman, 1990,* in the National Gallery of Victoria).

The central focus of the image, the waterhole 'at a sacred place near Rarragala' fittingly directs attention to the theme of water which was chosen by the artists at the start of this project. In this context it signifies both focus and vanishing point and, for Djalu, it is the site of greatest authority and ancestral power, a reflection of his right to be an artist.

In choosing to write about an image which is unconventional to western eyes, I have deliberately focused on that aspect of the project which took me beyond my expectations, and forced me to

reassess the effects of cross-cultural experience on visual form. How might it be read conventionally? As too disjunctive, as compromised by its stylistic diversity? Or as too didactic, an outcome of the organisers' interventions? From different vantage points, I find I can understand the image in quite different ways: as an inventory, or as a kinship diagram — or as a map, a record of an historical intersection, a narrative of the event — or as a form of homage to the indigenous presence in the project. In each or all of these instances, I find I am forced to re-think a whole range of assumptions about my conventional ways of seeing.

Conclusion

Implicit in every work of art is the internal narrative of its own making. However in the case of works of art made collaboratively, such narratives become central to the ways in which such works may be interpreted and understood. As Vivienne Binns has commented to me, there is a sensual intellectual pleasure which derives from the creative uncertainty such projects engender. Each element of the work resonates with a particular kind of sociality, which is the result of its collaborative process, and each element poses questions about the nature of creativity itself.

The circumstances in which each of these works was produced derive from the conjunction of a particular set of creative displacements — of media, of cultural context, of the circumstances of the engagement between artists. Thus these kinds of work possess specific kinds of internal relationships which translate to the nature of the human relationships, protocols, creative tensions, and the narrative possibilities of the artists' engagement with each other's skills and knowledge.

What are the necessary conditions for a successful collaboration, and how does one judge success? Like any relationship, there is a necessity for trust, commitment, stimulus, curiosity and a willingness to step outside one's familiar frame. In all of these works runs the theme of the nature of the creative relationship and the necessity for each participant to engage with the other's values at a deep level.

And for this viewer, the outcome is deeply satisfying for its 'sensual intellectual' dimension.

Nigel Lendon

In 1997 Nigel Lendon was a Visiting Fellow at the ANU Centre for Cross-Cultural Studies, where he wrote the catalogue introduction from which the second part of this essay derives. The writer is grateful for assistance with finetuning from Robin White and critical commentary from a number of friends: Vivienne Binns, Tim Bonyhady, Claire and Patsy Payne.

1 The first mats were made on the understanding that any proceeds would be split three ways. Several sets have been sold so far in New Zealand, plus one to the National Gallery of Australia and one to the Queensland Art Gallery, plus individual commissions. The proceeds have gone towards funding the activities of Teitoiningaina, including housing for women at the Centre and the provision of training to give the women greater economic independence.

2 In only two Fijian islands do people make *masi* (tapa) — Moce in the Lau group and Vatulele near the main island Viti Levu.

3 The sequence of application of colours is determined by tradition: first is black *loaloa* then the light brown *tassina* (the application of *kesa*, mangrove juice by itself, patted on with netting for underneath padding, producing the textured surface), then brown *umea* and then the final black. Pigment is applied with *tata* — sponge made of shredded tapa, wetted with mangrove juice *kesa*, rolled in the red clay. Black comes from soot made by burning kerosene in an old rusty biscuit tin. In earlier days, black was derived from burning the seeds of the *sikeci* tree.

4 Roger Neich and Mick Pendergrast, *Traditional Tapa Textiles of the Pacific*, London: Thames and Hudson, 1997, p.102.

5 *The Meeting of Waters: An exhibition of prints and works by artists from the Australasian print project*, Darwin: NTU, 1997.

6 The staff of the printmaking studio of the Department of Fine Arts (now called Northern Editions) who initiated and coordinated this project were Basil Hall, Jan Hogan and Leon Stainer. The advisor/ curators who nominated the artists were James Bennett, Alison Carroll, and the writer. The first project was funded by the Australia Council, with a second in 1998 funded by SOCOG.

THE CROSS-CULTURAL EXPERIENCE

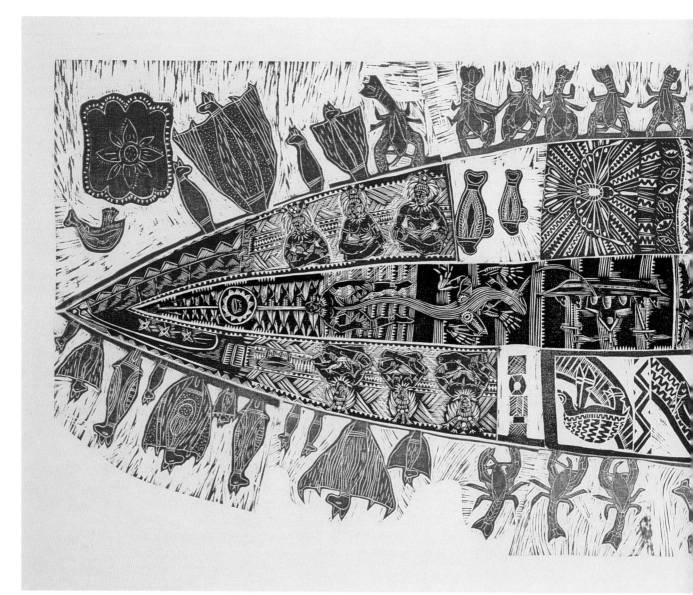

Michel TUFFERY, VARIOUS ARTISTS
A canoe of many passengers 1998 woodcut

A canoe of many passengers resulted from a workshop run by
Michel Tuffery at the Banggu Minjaany Arts and Cultural Centre
in 1998. Indigenous students from first year, diploma and advanced
year, and non-indigenous staff assisted Michel with cutting and printing
the block for this project, including: Andrew Warrior, Avril Ahwang,
Warren Brim, Ethel Sambo, Bianca Mahoney, Glen Mackie,
Anna Eglitis, Shiela Sparks and Vicki Igibi.

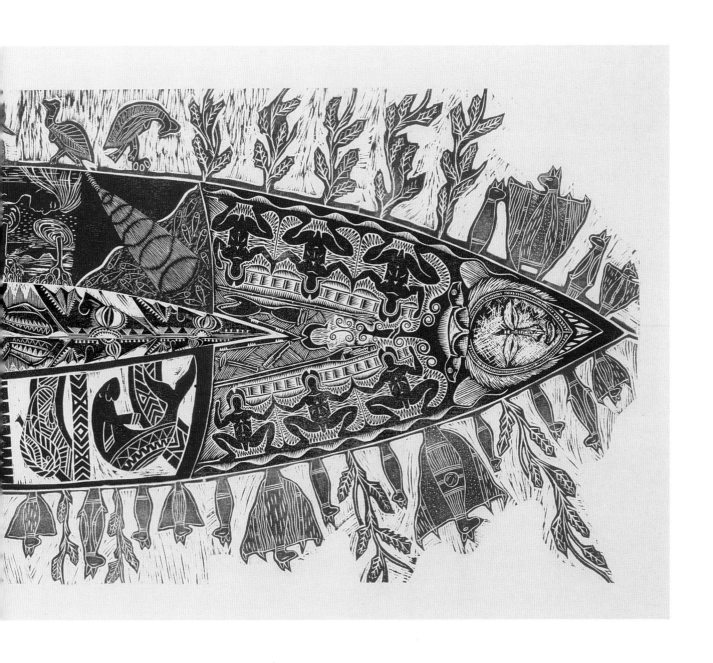

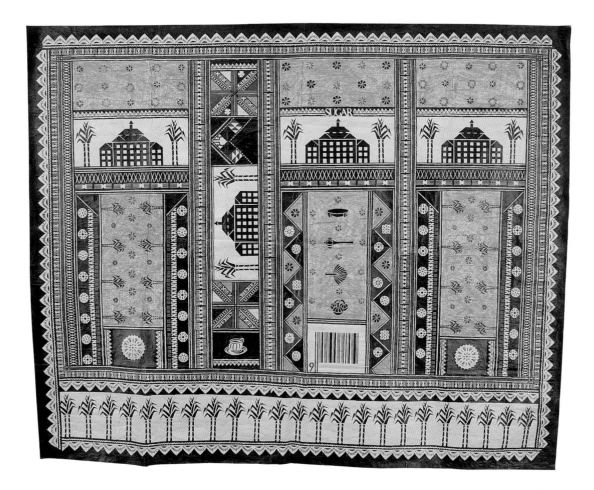

Robin WHITE, Leba TOKI
Tea, Milk, Sugar
2000
stencil print

Tea, Milk, Sugar is a collaborative work between Robin White and Leba Toki. It was made in New Zealand at White's studio, from tapa that was produced in Fiji and is printed in natural pigments through cut plastic stencils.

White and Toki use traditional Fiji islands tapa design and incorporate objects relating to tea, milk and sugar. These are symbols of colonial rule (Fiji's economy is predicated on sugar; Kanakas were blackbirded to Australia to work on sugar plantations and Indians migrated

to Fiji to work on sugar plantations). The image also incorporates cows, glasses of milk and barcodes, all symbols of western influence.

However, the tapa is not overly didactic, the images are also personal — Robin's father worked in the sugar mill depicted in the tapa and she has also incorporated the *moko* (facial tattoo design) of her great grandmother, who is Maori.

Some people say 'that's only the Fijian that can do that', and 'that's only the *palagi* that can do that'. But myself and Robin we decided we try to work together. So we start with the tapa and consult about what to do.

Leba Toki

We wanted to produce something that could not have been done by either of us on our own. So this collaboration has been a journey that has taken both of us to places we have never been to before.

Robin White

The *Cakacakavata* project: *Tea, Milk, Sugar*

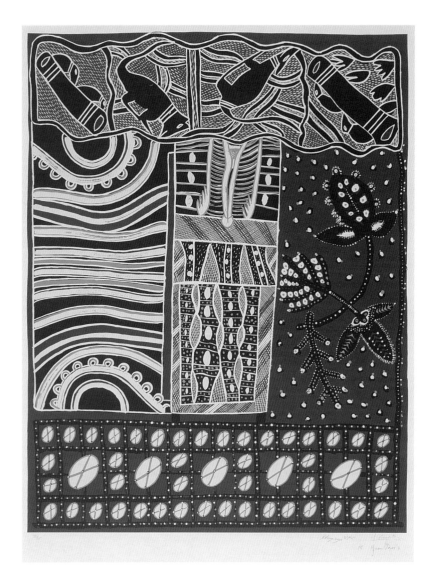

Peter ADSETT, Yuan MOR'O OCAMPO, Djalu GURRUWIWI, Ardiyanto PRANATA, Dhopia YUNUPINGU
Gapu, tubig, air, water 1997 screenprint

In Darwin, in July 1997 five artists from the South-East Asia region participated in an exchange of ideas about 'place' as part of the Australasian Print Project. By the time they had combined to work on this print, each was aware of their adopted kin relationships and responded accordingly. Its theme of water was chosen at the start of the project.

Mor'O Ocampo consulted with Dhopia on the form, colour and structure of his section, according to the totemic references to quail and crocodile eggs, to which he could refer through his kinship association. Ardiyanto's section stresses his own traditional cultural roots in batik, and the wider cultural ties within the region. Peter Adsett's section refers to the stream which flows between the two waterholes where he lives at Humpty Doo, and to the waterlily leaves Djalu had seen there. Dhopia completed the cycle by painting her own Yirritja moiety motif of *larrakitj*, the hollow log coffin with *djirrikitj*, the quail, who lay her eggs inside, and *wan'kurra*, the bandicoot, who is looking for *ngatha* or food. Djalu's central image is a part of the story of Bol'ngu, the Thunderman, who sends down *djambuwal* (the waterspout), which creates the freshwater waterhole in the ocean.

102

Peter ADSETT, Yuan MOR'O OCAMPO,
Djalu GURRUWIWI, Ardiyanto PRANATA,
Dhopia YUNUPINGU
Gapu, tubig, air, water II 1999
etching and aquatint

This collaborative work was created during
the second phase of the Australasian Print Project

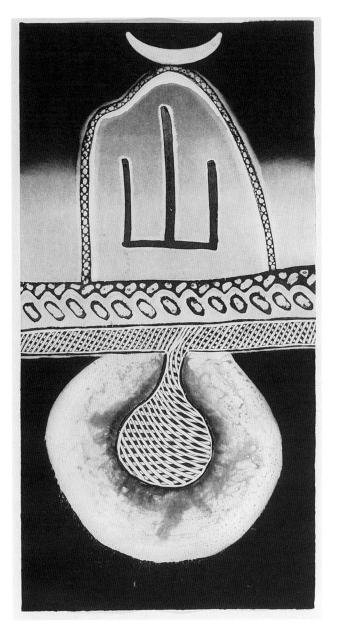

Panel 1: Mor'O Campo (top) and Peter Adsett (bottom)

The cross-hatched section through the centre
of the entire piece represents water. Each artist
determined the position of the water, and Djalu
approved the use of the hatching, done by his
wife Dhopia for each of the artists. In panel 1
the water becomes a billabong on Peter Adsett's
property at Humpty Doo, Northern Territory.
It then flows through Yogyakarta and Arnhem
Land in panels 2–3, before becoming the
Pasig River, which winds through Manila
in the Philippines.

103

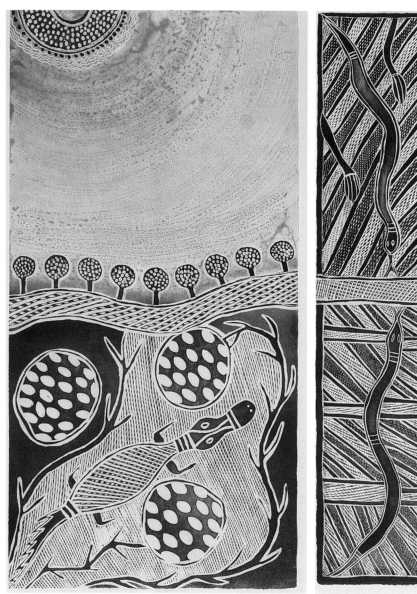

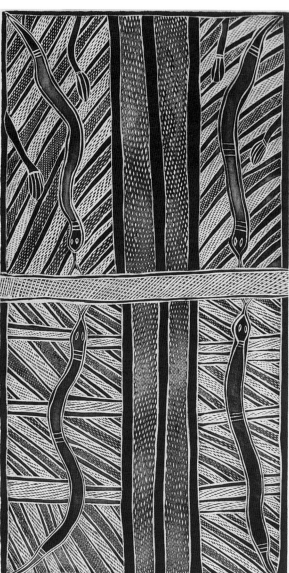

Panel 2: Dhopia Yunupingu (top) and Ardiyanto Pranata (bottom) Panel 3: Djalu Gurruwiwi

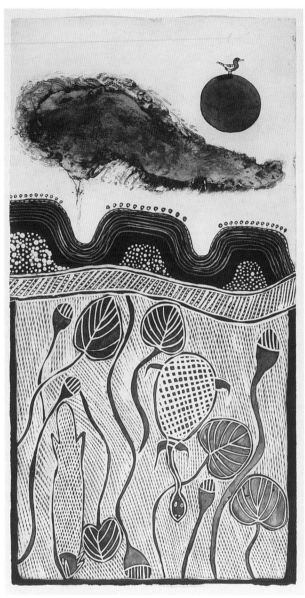

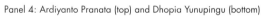

Panel 4: Ardiyanto Pranata (top) and Dhopia Yunupingu (bottom) Panel 5: Peter Adsett (top) and Mor'O Campo (bottom)

BIOGRAPHICAL NOTES

Peter ADSETT was born at Gisborne, Aotearoa New Zealand in 1982 and studied at the Palmerston North Teachers College and Massey University. In 1981 he was awarded the Montana Art Award. The following year he moved to Australia where he has taught at many educational institutions. He presently lives in Darwin and has worked extensively with Aboriginal people.

(Timothy) AKIS was born in 1940 in Tsembaga Village, Simbai Valley, Madang Province. He started drawing whilst working as an interpreter during the 1960s, as a means of communicating complex ideas to visiting anthropologists. After visiting Port Moresby he focused more on drawing and experimenting with drawing techniques and limited edition screenprints of his work were also made. Akis' non-traditional style was not restricted by the artistic conventions of his people, nor was it inhibited by Western education. He died in 1984.

Jakupa AKO was one of Papua New Guinea's most successful artists. He was born at Meganagu village in the Bena Bena valley of the Eastern Highlands c.1942. As a cleaner at Goroka Teachers College he began to draw, and with encouragement from staff, began attending classes. Jakupa returned to his village in 1972, but was soon in demand for major commissions. These led to a scholarship at the Creative Arts Centre at Port Moresby in 1974. As well as paintings and drawings, Jakupa produced appliqued works and some remarkable prints. He exhibited internationally throughout his career and received an MBE for his service to art in 1981. He died in 1999.

Nazareth ALFRED was born on Waiben (Thursday Island) and grew up on Masig (Yorke Island) in the Torres Strait. She completed a Diploma of Applied Science (Museum Studies) before graduating from the University of Canberra with a degree in Applied Science, majoring in Cultural Heritage Management. She is now the Assistant Curator of Indigenous Australian Art at the National Gallery of Victoria. Her art is inspired by the spirituality of her ancestors; their relationship with the sea is especially important to her.

Jean Baptiste APUATIMI was born c.1940 at Pularumpi in the Northern Territory. Her language is Tiwi and she now lives in Nguiu, Bathurst Island. Taught to paint by her husband Declan Apuatimi, her work both as a painter and printmaker is strongly based on her Tiwi heritage.

Toni BAILEY was born in Canberra in 1974. She completed a Bachelor of Fine Arts (Visual Arts — Printmaking) at Canberra School of Art in 1995 and is currently undertaking a Post-Graduate Diploma (Art History and Curatorship) at ANU. Toni was associated with Studio One National Printmaking Workshop from 1995–99 and has worked, taught and exhibited extensively over the last five years, including close partnership with Aboriginal artists.

Frederick BAIRA was born on Waiben (Thursday Island), Torres Strait in 1954. His family is from Badu (Mulgrave Island). He has long had an interest in art but worked until recently as a seaman. He completed a Diploma in Aboriginal and Torres Strait Islander Visual Arts at the Tropical North Queensland Institute of TAFE, Cairns in 1997, and has moved on to study for his Bachelor of Visual Arts at the James Cook University, Townsville.

Tatipai BARSA was born on Mer (Murray Island), on the eastern side of the Torres Strait in 1967 and gained his Associate Diploma from the Aboriginal and Torres Strait Islander Visual Arts course at the Tropical North Queensland Institute of TAFE, Cairns. His images are drawn from his island home and the life of the tropical seas. A painter and printmaker who exhibits frequently, a series of his large linocut prints is displayed in the new Cairns Convention Centre.

Donna BURAK was born in Milikapiti on Melville Island in 1972. As a Tiwi woman she uses her skills to pass on the traditions and language of her people. She produces paintings, etchings and linocut prints. Donna won the Australian Heritage Commission National Youth Art Award in 1996.

Fatu FEU'U was born at Poutasi, Falealili, West Samoa in 1946 and raised in a small village where he was exposed to a variety of traditional art forms. In 1966 he moved to Aotearoa New Zealand. His work is an expression of pride in his Samoan culture and features the motifs and symbols of traditional Samoan and Pacific art in a variety of mediums. He has played a crucial role in helping form funds and groups to support and educate other Polynesian artists.

Nancy GAYMALA was born in 1935 and is from north-east Arnhem Land. She works through the Buku Larrnggy Arts and Nambara Arts and Craft Centres. Nancy depicts *Baru* (ancestral crocodile) themes in her bark painting, woodcarvings, weavings and prints.

Anne GELA was born on Moa (Banks Island), Torres Strait in 1953. A founding member of the SAIMA Torres Strait Islanders' Corporation in Rockhampton, she is presently working as an Arts Coordinator for the corporation. She was the first Torres Strait Islander artist to receive an Individual Arts Grant from Arts Queensland.

Djalu GURRUWIWI was born c.1940. He is a senior Galpu man and is a specialist didgeridoo maker and player. Djalu paints in ochres on bark and hollow logs, and also produces prints.

Basil HALL was born in Melbourne, Victoria in 1954 and studied at the Australian National University and Canberra School of Art. In 1987 he was appointed Director of Studio One National Print Workshop, a position he held until 1994, and was involved with print production by many Aboriginal and Torres Strait Islander artists. In 1995 Basil won a Churchill Fellowship and travelled to Europe and the USA. From 1996–99 he was lecturer in charge of the Aboriginal and Torres Strait Islander Printmaking Workshop at Northern Territory University. He is currently the Editioning Manager of the University's Northern Editions print workshop.

John HOVELL was born in 1938 and has a Bachelor of Fine Arts Degree and a Diploma of Education. He lives at Te Araroa on the east coast of North Island, where he first went to teach and to be near his mentor, the Maori carver Pine Taiapa. Hovell is a painter and has produced a number of lithographs.

Ellen JOSÉ was born in Cairns, North Queensland in 1951, of Torres Strait Islander decent. After leaving school she worked as a commercial artist and in 1976 was awarded a Certificate of Applied Art from Seven Hills Art College, Brisbane. Ellen continued her studies in Melbourne, gaining a Diploma of Fine Art from Preston Institute of Technology in 1978 and a Diploma of Education from Melbourne State College in 1979. She has worked with the Victorian Aboriginal Service and the Education Department. Since 1982 Ellen has travelled and exhibited widely, both nationally and internationally. As well as producing paintings, prints and installations, Ellen studies classical music.

Robyn KAHUKIWA was born in Sydney in 1941. She moved back to Aotearoa New Zealand in 1960, and now lives in Rotorua. She has focused on her Maori cultural heritage and is considered to be a leading Maori artist. Robyn is a prominent supporter of Maori rights and the power and prestige of Maori women both as writers and artists. She is a member of Maori Artists and Writers, Nga Puna Waihanga and Haeata Maori Womens Collective. Her work has been exhibited nationally and internationally since the early 1980s. As well as painting, drawing, printmaking and sculpture, Robyn writes and illustrates children's books.

Patrice KAIKILEKOFE is an artist of Futunian heritage (Wallis and Futuna Islands) who was born in New Caledonia in 1972. He studied at the Ecole d'art de Noumea 1990–92 and then Art, Craft and Design and Oceanic art history in New Zealand. Patrice now lives and works in New Caledonia and has exhibited extensively in the region. Both he and Michel Tuffery made an enormous impact at the *Asia-Pacific Triennial of Contemporary Art* in 1999 for their opening night performance *Bull fight*.

Fatima KANTILLA was born in 1971. In 1991, together with a group of Tiwi artists, she attended an etching and lithography workshop at the Canberra School of Art, where she worked closely with the printer Theo Tremblay. Fatima was a member of the Munupi Arts Association on Melville Island and produced a wide range of art works including prints and batik. She died in September 2000.

Mathias KAUAGE began drawing after seeing an exhibition of Akis' work. Subsequently he was taught the art of woodblock printing by Georgina Beier, one of Akis' teachers. He also learnt the techniques of copper beating. Kauage uses traditional design techniques combined with religious, imagined and modern subjects. He is the most successful and well-known of the contemporary Papua New Guinea artists and in 1997 was awarded the OBE for his services to art.

Martin KING was born in Melbourne in 1957. He completed a Graduate Diploma of Fine Art and Design, Caulfield Institute of Technology in 1978, a Post-Graduate Diploma in Fine Art in 1982 at Sydney College of the Arts and a Master of Fine Arts from Monash University in 1999. He has lectured in lithography and etching at the Warrnambool Institute of Advanced Education in 1985; in Graphic Investigation at the Canberra School of Art 1986–7; and in printmaking at the Victorian College of the Arts, 1993–94. Martin has been Senior Printer with the Australian Print Workshop since 1989, during which time he has worked with many of Australia's most important artists. He has also undertaken a number of printmaking projects with Aboriginal artists in remote communities of Australia.

David LASISI was born in Lossu, New Ireland in 1955 and was among the first group of students with higher secondary education to enter the tertiary system. From 1975–79 he worked at the Creative Arts Centre / National Arts School, concentrating on screenprinting. He has also worked on a number of public commissions for murals and sculpture. Most of David's prints works are either derived from, or accompanied by, traditional Papua New Guinean stories or poems. He was also involved in the theatre.

Joe LINDSAY (SALE) was born in the Solomon Islands in 1964.

Marion MAGUIRE was born in Christchurch in 1962. She studied for a Bachelor of Fine Arts at the University of Canterbury. She later moved to America to attend a professional Print Training Program, on completion of which she returned to New Zealand. Her work explores the feminine psyche through its physicality. Marion established The Limeworks in 1987 and PaperGraphica, Christchurch in 1995.

Banduk MARIKA of the Rirratjingu people of north-east Arnhem Land is a prominent Australian printmaker. Born in 1954, she first came to prominence as an artist in the early 1980s. Banduk began producing linocuts of her inherited Dreaming stories, a departure from the more established and accepted practice of bark painting for which her region and family are famous. Her father was the famous bark painter Mawalan Marika, and her brother Wandjuk was an artist and heavily involved in copyright issues. Banduk has taken on such roles herself; she was a member of both the Aboriginal Arts Board of the Australia Council and the National Gallery of Australia Council. She has an established studio in her home town of Yirrkala in Arnhem Land as well as working in the cities for periods of time. She lived and worked in Sydney 1980–88 and has undertaken artist-in-residences in universities in Canberra and Adelaide. She was the recipient of several Aboriginal Arts Board Grants in 1985, 1986 and 1987.

Robert MAST was born on Waiben (Thursday Island), Torres Strait in 1976. He learnt art from his parents and grandparents on Badu (Mulgrave Island) and started to paint and carve traditionally when he was in boarding school at Saint Augustine's College, Cairns in 1989. After completing an Access Course at the James Cook University, Cairns, Robert decided on further study and gained entry to the Aboriginal and Torres Strait Islander Visual Arts Course at the Tropical North Queensland Institute of TAFE, Cairns and in 2000 completed his Advanced Diploma in Visual Arts. 'We are all striving to enforce our culture on the generations to come so we can be recognised as true Torres Strait Islanders.'

Paratene MATCHITT was born at Tokomaru Bay in East Cape, Aotearoa New Zealand in 1939. He attended St Peter's Maori Boys College studying at Auckland Teachers College and later undertook a specialist arts and crafts course at Dunedin. The Maori carver Pine Taiapa was particularly influential in his development. Matchitt is one of the prime instigators of new Maori art, expressing the traditions of the past in forms accessible to a contemporary world. He produces paintings, carvings, murals and prints.

Yuan MOR'O OCAMPO is a multi-media, installation and performance artist based in the Philippines. He studied at the College of Fine Arts, University of the Philippines. From 1984–86 he received a Dharmasiswa Republik Indonesia Scholarship to study mask making at the Faculty of Fine Arts and Design in Indonesia. He is a representative of the Art Association of the Philippines and is an art teacher, visual arts mentor and cultural officer.

Martin MORUBUBUNA was born in the Trobriand Islands in 1957 and began working at the Creative Arts Centre in Port Moresby in 1974. He worked mainly with screenprints, lithographs, and woodcuts, which reflect his training in Trobriand woodcarving by his grandfather. Many of Martin's prints illustrate stories from the Trobriand Islands using known imagery from the region, however he shows a greater concern for realism over stylised motifs.

Maryanne MUNGATOPI was born on Melville Island in 1966 and is a senior artist with the Jilamara Arts and Crafts Association on Melville Island. Maryanne is particularly noted for her ironwood carvings and paintings using natural pigments on paper, canvas and bark. She has been making prints since 1995 and has worked at the Australian Print Workshop, Melbourne. Maryanne currently lives in Milikapiti, Melville Island.

Marrnyula 2 MUNUNGGURR was born in 1964 and is a member of the Djapu clan. She depicts both traditional values and the practices and images of contemporary Arnhem Land life. While relating a contemporary narrative in her work, Marrnyula 2 maintains a traditional ochre palette.

Mundul MUNUNGGURR was born in 1951 and is a member of the Djapu clan. She works at the Buku Larrnggay Mulka print studio, Yirrkala as an Associate printer. She is a Yolngu printmaker and works with lino printing on paper.

Janice MURRAY was born on Melville Island in 1966, and presently lives at Milikapiti. She is well known as a painter who uses natural pigments on paper, canvas and bark. Her first prints were the linocuts she produced at the Australian Print Workshop, Melbourne in 1995. She has also produced etchings.

Dennis NONA was born on Waiben (Thursday Island) in the Torres Strait in 1973, spending his childhood at his family home on Badu (Mulgrave Island). He travelled to Cairns where he completed his Associate Diploma of Aboriginal and Torres Strait Islander Visual Art at the Tropical North Queensland Institute of TAFE, Cairns. He then continued his studies at the Australian National University, Canberra School of Art, where he was awarded his Bachelor of Fine Art (Printmaking). He has since taken up a number of residencies and held several exhibitions. His intricately engraved prints are based on traditional stories from the Torres Strait. In 2000, Dennis established a print workshop at the Mualagal Minneral Arts Centre on Moa (Banks Island).

Laurie NONA was born on Waiben (Thursday Island) in 1975 of Badu (Mulgrave Island) descent. It was here that he spent his early childhood in the islands' traditional cultural surroundings. He completed his education on Thursday Island and then at Saint Augustine's College in Cairns. He is currently a Police Liaison Officer in Cairns, and in his spare time studies Indigenous Visual Arts with the Centre for Aboriginal and Torres Strait Islander Studies at the Tropical North Queensland Institute of TAFE, Cairns. 'My greatest dream is to see the young people of my culture understand and value the history of our *Kuikumabaigal* (Elders of Old People).'

Kathryn NORRIS was born in Brisbane in 1971 and is presently studying for her secondary teacher qualifications at James Cook University, Cairns. Her work focuses on the period after the arrival of Christianity ('The Coming of the Light') in the Torres Strait. While her subject matter is historic her images are modern; she also uses modern mediums, such as pastels.

Josette ORSTO was born in 1962 and is the daughter of Jean Baptiste and Declan Apuatimi. Trained by her father in the art of carving and painting, Josette is prolific in many different media including acrylic and ochre on canvas and paper, batik, etching, linocut, woodcut, lithography and wood sculpture.

Reppie ORSTO was born in Nguiu on Bathurst Island in 1959 and works with the Munupi Arts Association on Melville Island. She is a painter and printmaker; her work has also been translated into carpet design.

Ardiyanto PRANATA is a batik artist and painter in Indonesia. He trained as an Agricultural Technologist but then turned his focus to art. He is now also a lecturer at the Theatre Department of the Indonesian Institute of Art.

John PULE was born in Liku, Niue in 1962 and has lived in Aotearoa New Zealand since 1964. A painter, printmaker and performance artist, he is also an accomplished writer. In recent years he has taken an increasing interest in the history, mythology and make up of Niue. His paintings and prints use the form and the colour range of Nuiean tapa cloth.

Thecla Bernadette PURUNTATAMERI was born in 1971 in Nguiu on Bathurst Island and is one of a family of Tiwi carvers, painters and designers. She derives her imagery from the traditional motifs of this group and has exhibited since 1990. A painter on paper and canvas, she also produces etchings and linocut prints. Thecla is a member of Munupi Arts Association on Melville Island, where she is an artist supervisor and trainer for young artists.

Brian ROBINSON was born on Waiben (Thursday Island) in 1974, later moving to the mainland to study. He completed his Associate Diploma of Aboriginal and Torres Strait Islander Visual Arts at the Tropical North Queensland Institute of TAFE Cairns, as well as numerous certificates and went on to gain an Advanced Certificate in Visual Arts (ATSI). As well as pursuing his career as a printmaker, painter and sculptor, he is active as a writer and curator. He is presently Curator of Indigenous Art at the Cairns Regional Gallery.

Nino SABATINO was born on Waiben (Thursday Island) in 1975 and is from Kiriri (Hammond Island). He attended the Tropical North Queensland Institute of TAFE, Cairns, graduating with his Associate Diploma of Aboriginal and Torres Strait Islander Visual Arts in 1994. His work focuses on his people's traditions and the spiritual and cultural connection the Torres Strait Islanders have with the sea and its creatures.

Alick TIPOTI was born in 1975 on Waiben (Thursday Island), and had his initial education on Badu (Mulgrave Island) and Ngurupai (Horn Island) before moving to Cairns. He completed an Associate Diploma of Aboriginal and Torres Strait Islander Visual Art at Tropical North Queensland Institute of TAFE (1995) and his Bachelor of Visual Art (Printmaking) from the Australian National University, Canberra School of Art. In 1998 Tipoti was awarded the Lin Onus Youth Art Prize in the 4th National Indigenous Heritage Art Awards. He has exhibited widely.

Giovanni TIPUNGWUTI started carving designs of birds and animals into woodblocks in the late 1960s. Together with Bede Tungutalum, he established the fabric printing company Tiwi Designs in 1969. His designs are often influenced by traditional motifs and include representations of the bush life around the area of Bathurst Island.

Leba TOKI was born on 5 April 1951in the village of Nasau, Moce Island, which is in the Lau Group, Fiji. Leba learnt the art of tapa making from her mother and also during her time as a pupil at the the Moce District Primary School. She is from one of the only two islands in Fiji that make tapa. Leba now lives in Lautoka and is married with four children and three grandchildren.

Theo TREMBLAY was born in the United States in 1952 and arrived in Australia in 1977. He first became involved in printmaking with both urban and Northern Australian Aboriginal artists in 1983 whilst working with the Printmaking Workshop at the Canberra School of Art. He moved from the Canberra School of Art to learn more about Aboriginal art and art education and has returned there repeatedly since 1983.Theo also had a long association as specialist lithographer with Studio One National Print Workshop. He has taught at the Northern Territory University and Tropical North Queensland Institute of TAFE, Cairns. Theo currently lives in Bungendore, New South Wales.

Michel TUFFERY was born in Aotearoa New Zealand in 1966 of Samoan and Palagi decent. He combines both these cultural heritages in his art. Michel graduated with Honours in his Diploma in Fine Arts, Otago Polytechnic, Dunedin. He also studied at the University of Hawaii at Manoa School of Fine Arts. In 1987 he travelled throughout the Pacific running art workshops for the local children. His work ranges across many media and modes of expressing his heritage. He has produced many prints, and most recently has choreographed elaborate performances. Both he and Patrice Kaikilekofe made an enormous impact at the *Asia-Pacific Triennial of Contemporary Art* in 1999 for their opening night performance *Bull fight*.

Bede TUNGUTALUM was born at Nguiu, Bathurst Island, in 1952. While attending Xavier Boys School at Nguiu, he was taught how to cut woodblocks for printing. His earliest prints date from the late 1960s. In 1969, together with Giovanni Tipungwuti, Bede established Tiwi Designs, to produce printed fabric which incorporated traditional designs. He has travelled to Papua New Guinea and Canada, and was artist-in-residence with his wife, Francine, at Flinders University in South Australia. Bede works in carved and painted wooden sculpture, lino and textile prints, etchings and carvings. He has exhibited widely.

Gunaimulk WANAMBI was born in 1957 and is a member of the Marrakulu clan. She is linked to Buku Larrnggay Mulka Arts and the Nambara Arts and Craft centres. Her work includes painting on bark, and carving and painting wooden objects.

Robin WHITE is a major New Zealand artist. She is a painter as well as a printmaker and drawing is an important part of her work. Robin was born in Te Puke, Aotearoa New Zealand on 12 July 1946. After graduating from the Elam Art School in 1967 and Auckland Secondary Teacher's College in 1968, Robin lived for three years at Bottle Creek, Paremata and then moved to Dunedin. In 1982 she and her family moved to the Republic of Kiribati where they lived until 1999. She was artist-in-residence at the Christchurch Polytechnic School of Art in 1992 and the Canberra School of Art in 1995 and 1996. Robin now lives in Masterton, New Zealand.

Pedro WONAEAMIRRI was born at Goose Creek, Melville Island in 1974. He has worked with the Jilamara Arts and Craft centre since 1991, and has been both President and Vice-President of the Executive Committee of the Centre. Pedro paints on paper, canvas, and bark and is an accomplished carver. He is one of the ceremonial leaders of his community and exhibits widely. He has produced prints at the Australian Print Workshop, Melbourne.

Cecil King WUNGI was born in 1952 in Bundi Village in Madang Province. In1976 he was awarded a three year scholarship to the National Arts School in Papua New Guinea. Five exhibitions of his work were held there between 1978 and 1982. Cecil worked in his own distinctive style in the non-traditional media of screenprinting, depicting his inner world rather than his external environment and presenting personal stories and reflections which related to the traditional myths and stories of his village. He died in 1984.

Dhopia YUNUPINGU is part of an actively producing artistic family. As the 'mother' in this group she is called upon to guide and assist in the others work. She produces weavings and has produced a number of prints; she also collaborates with her husband, Djalu Gurruwiwi, with his ochre bark paintings.

LIST OF ARTISTS AND WORKS IN THE EXHIBITION

Prints by Aboriginal artists from Arnhem Land

Banduk MARIKA
Rirratjingu people
born Australia 1954

Miyapunawu Narrunan — Turtle hunting Bremer Island
1989 Canberra
linocut, printed in colour, from multiple blocks
58.0 x 57.0 cm.
printed by Rodney Gregory at the Canberra School of Art
Gift of the artist 1990
1990.792.

Yalangbara Suite
2000 Darwin
linocuts, printed in black ink, from one block;
screenprints, printed in grey ink, from one stencil on white wove Magnani paper
26.6 x 20.2 cm.
29.8 x 20.4 cm.
20.6 x 28.8 cm.
30.3 x 21.4 cm.
30.3 x 21.4 cm.
28.8 x 20.2 cm.
relief printed by Basil Hall, stencil printed by Simon White at Northern Editions
Gordon Darling Australasian Print Fund 2000
2000.449.1
© Banduk Marika, 2000/licensed by VISCOPY, Sydney 2001

Marrnyula 2 MUNUNGGURR
Djapu people
born Australia 1964

Mundul MUNUNGGURR
Djapu people
born Australia 1951

Boliny WANAMBI
Marrakulu people
born Australia 1957

Gundimulk WANAMBI
Marrakulu people
born Australia 1957

Dhuwarrwarr MARIKA
Rirratjingu people
born Australia 1946

Naminapu MAYMURU-WHITE
Manggalili people
born Australia 1952

Djolu YUNUPINGU
Gumatj people
born Australia 1945

Nancy GAYMALA 1 YUNUPINGU
Gumatj people
born Australia 1935

Nyapanyapa YUNUPINGU
Gumatj people
born Australia

Barrupu YUNUPINGU
born Australia

Djapirri MUNUNGIRITJ
born Australia

Mananu WUNUNGMURRA
Dhalwangu people
born Australia

Maringgurrk MARAWILI
born Australia

Birrala YUNUPINGU
born Australia

Patrick WHITE
born Australia

Yirritja Ga Dhuwa Ngatha
1999 Yirrkala, Northern Territory
linocuts, printed in black ink, each from one block on two sheets of white wove paper
74.0 x 187.0 cm. (each printed image)
printed by Basil Hall, assisted by Marrnyula 2 Mununggurr and Nyarlung Wunungmurra, at Buku Larrnggay Mulka Arts Centre
Gordon Darling Australasian Print Fund 2000.43.1-2

Prints from the Tiwi Islands

Jean Baptiste APUATIMI,
Tiwi people
born Australia 1940

Kulama
1999 Melville Island, Northern Territory, printed Fitzroy, Victoria
hard ground etching, printed in two colours, from one copper plate on white wove paper
50.0 x 29.5 cm.
printed by Martin King at the Australian Print Workshop
Gordon Darling Australasian Print Fund 2000
2000.250

Parlini Jilamara
1999 Melville Island, Northern Territory, printed Fitzroy, Victoria
hard ground etching, printed in two colours, from one copper plate on white wove paper
50.0 x 29.5 cm.
printed by Martin King at the Australian Print Workshop
Gordon Darling Australasian Print Fund 2000
2000.251

Donna BURAK
Tiwi people
born Australia 1972

Kalama and Jilmara
1991 Canberra
lithograph, printed in black ink, from one stone on white wove paper
30.0 x 35.0 cm.
printed by Theo Tremblay at the Canberra School of Art
1991.839

Fatima KANTILLA
Tiwi people
born Australia 1971 died Australia 2000

This mob going hunting
1991 Canberra
lithograph, printed in black ink, from one stone on white wove paper
36.0 x 48.0 cm.
printed by Theo Tremblay at the Canberra School of Art
1991.838

Maryanne MUNGATOPI
Tiwi people
born Australia 1966

Jurrukukuni and Malakaninga
1998 Fitzroy, Victoria
lift ground aquatint, printed in two colours, from one copper plate with roll up on white wove paper
55.0 x 39.0 cm.
printed by Martin King at the Australian Print Workshop
Gordon Darling Australasian Print Fund 2000
2000.258

Objects used Kulama Ceremony
2000 Fitzroy, Victoria
etching and lift ground aquatint printed in two colours, from one copper plate with colour roll up on paper
59.0 x 87.5 cm.
printed by Martin King at the Australian Print Workshop
Gordon Darling Australasian Print Fund 2000
2000.260

Janice MURRAY
Tiwi people
born Australia 1966

Flying fox and bamboo at Muranapi
2000 Fitzroy, Victoria
etching and lift ground etching, printed in three colours, from two copper plates on white wove paper
89.5 x 59.0 cm.
printed by Martin King at the Australian Print Workshop
Gordon Darling Australasian Print Fund 2000
2000.262

Josette ORSTO
Tiwi people
born Australia 1962

March fly dreaming
1991 Canberra
lithograph, printed in black ink, from one plate on cream wove paper
34.0 x 43.6 cm.
printed by Theo Tremblay at the Canberra School of Art
1991.840

Reppie ORSTO
Tiwi people
born Australia 1959

Jarrikarlami (Turtle)
1991 Canberra
lithograph, printed in black ink, from one plate
on cream wove paper
42.4 x 32.0 cm.
printed by Theo Tremblay at the Canberra
School of Art
1991.841

Thecla Bernadette PURUNTATAMERI
Tiwi people
born Australia 1971

Pukumani poles
1991
screenprint, printed in colour, from multiple
stencils on thick wove paper
66.0 x 46.4 cm
1992.817

Giovanni TIPUNGWUTI
Tiwi people
born Australia ? died Australia1993

Three men cooking fish
1969 Bathurst Island, Northern Territory
woodcut, printed in black ink, from one block
on cream fibrous paper
26.8 x 31.4 cm.
Gordon Darling Australasian Print Fund 1989
1989.705

Two fishermen
1969 Bathurst Island, Northern Territory
woodcut, printed in black ink, from one block
on cream fibrous paper
20.6 x 24.0 cm.
Gordon Darling Australasian Print Fund 1989
1989.707

Bede TUNGUTALUM
Tiwi people
born Australia 1952

Man with spear
c.1969 Bathurst Island, Northern Territory
woodcut, printed in black ink, from one block
on cream fibrous paper
25.0 x 13.0 cm.
Gordon Darling Australasian Print Fund 1989
1989.704

Man with spear and fish
c.1969 Bathurst Island, Northern Territory
woodcut, printed in black ink, from one block
on cream fibrous paper
24.4 x 14.6 cm.
Gordon Darling Australasian Print Fund 1989
1989.706

Stingray
c.1970 Bathurst Island, Northern Territory
woodcut, printed in black ink, from one block
on cream fibrous paper
30.0 x 30.2 cm.
Gordon Darling Australasian Print Fund 1989
1989.698

Owl dreaming (Self portrait)
1988 Canberra
linocut, printed in black ink, from one block on
paper
50.0 x 40.0 cm.
printed by Theo Tremblay at the Canberra
School of Art
Gordon Darling Australasian Print Fund 1989
1989.588

Pukumani poles
1988 Canberra
linocut, printed in colour, from multiple blocks
on paper
70.7 x 48.7 cm.
printed by Theo Tremblay at the Canberra
School of Art
Gordon Darling Australasian Print Fund 1989
1989.590

Pukumani poles 1
1988 Canberra
linocut, printed in black ink, from one block on
paper
32.2 x 49.8 cm.
printed by Theo Tremblay at the Canberra
School of Art
Gordon Darling Australasian Print Fund 1989
1989.589

Pedro WONAEAMIRRI
Tiwi people
born Australia 1974

Pukamani objects
2000 Fitzroy, Victoria
etching, lift ground aquatint in one colour,
printed from one copper plate on paper
89.5 x 59.0 cm.
printed by Martin King at the Australian Print
Workshop
Gordon Darling Australasian Print Fund 2000
2000.268

Prints from the Torres Strait Islands

Nazareth ALFRED
Island group: Central Island
Language: Kala Lagaw Ya
born Australia

Sea shells
1996 Canberra
from the folio *Stronglines*
etching, printed in black ink, from one plate on
cream wove paper
11.5 x 23.0 cm.
printed by Toni Bailey at Studio One Inc.
Gordon Darling Australasian Print Fund 1997
1997.1029.1

Frederick BAIRA
Island group: Western Island
Language: Kala Lagaw Ya
born Australia 1954

Past and the present
1997 Cairns
linocut, printed in two colours, from one block
on white wove paper
40.0 x 60.0 cm.
printed at Tropical North Queensland Institute
of TAFE, Cairns
Gordon Darling Australasian Print Fund 2000
2000.279

Invaders II
1997 Cairns
linocut, printed in two colours, from one block
on white wove paper
40.0 x 59.0 cm.
printed at Tropical North Queensland Institute
of TAFE, Cairns
Gordon Darling Australasian Print Fund 2000
2000.280

Tatipai BARSA
Island group: Eastern Island
Language: Meriam Mer
born Australia 1967

*Seasonal migration and the mating season
(Fish)*
1996 Canberra
linocut, printed in black ink, from one block on
white wove paper
100.0 x 65.0 cm.
printed by Studio One Inc.
National Gallery of Australia Studio One Inc.
Archive

*Seasonal migration and the mating season
(Squid)*
1996 Canberra
linocut, printed in black ink, from one block on
paper
100.0 x 65.0 cm.
printed by Studio One Inc.
Canberra Museum and Gallery

Anne GELA
Island group: Western Island
Language: Kala Lagaw Ya
born Australia 1953

Eyes of the sea
1993 Canberra
linocut, printed in colour, from one block on
white wove paper
47.6 x 62.2 cm.
printed at Studio One Inc.
National Gallery of Australia Studio One Inc.
Archive

Koedal: Crocodile hatching
1993 Cairns
linocut, printed in black ink, from one block;
hand-coloured on white wove paper
44.0 x 60.2 cm.
printed at the Tropical North Queensland
Institute of TAFE, Cairns
Gordon Darling Australasian Print Fund 1994
1994.1106

Ellen JOSÉ
Island group: Eastern and Western Island
Language: Kala Lagaw Ya/Meriam Mer/Torres
Strait Creole
born Australia 1951

Landscape
1987 Melbourne
linocut, printed in black ink, from one block on
thin laid paper
15.3 x 15.1 cm.
1988.403

Seascape
1987 Melbourne
linocut, printed in colour, from multiple blocks
on thin laid paper
15.2 x 15.0 cm.
1988.404

Robert MAST
Island group: Western Island
Language: Kala Lagaw Ya
born Australia 1976

Inheriting culture
1994 Cairns
linocut, printed in colour, from one block; hand-
coloured on white wove paper
50.0 x 41.5 cm.
printed at Tropical North Queensland Institute of
TAFE, Cairns
Collection: The artist

Dennis NONA
Island group: Western Island
Language: Kala Lagaw Ya
born Australia 1973

Ngaw Kukuwum
1996 Canberra
from the *Stronglines* folio
linocut, printed in black ink, from one block;
hand-coloured with synthetic
polymer paint on cream wove BFK Rives paper
61.4 x 49.8 cm.
printed by Basil Hall at Studio One Inc.
Gordon Darling Australasian Print Fund 1997
1997.1029.19

Ubirikubiri
1992 Canberra
linocut, printed in colour, from one block on
textured white wove Saunders paper
40.2 x 49.8 cm.
printed at the Canberra School of Art
1992.1539

Boi
1997 Canberra
linocut, printed in colour, from multiple blocks
on white wove paper
97.8 x 62.2 cm.
printed at Studio One Inc.
National Gallery of Australia Studio One Inc.
Archive

Laurie NONA
Island group: Western Island
Language: Kala Lagaw Ya
born Australia 1975

Lagau Dunalaig (Island lifestyle)
1998 Cairns
linocut, printed in white ink, from one block on
black wove paper
75.0 x 35.0 cm.
printed at the Tropical North Queensland
Institute of TAFE, Cairns
Gordon Darling Australasian Print Fund 2000
2000.287

Giethalieth Adthaik (Dancing like a crab).
1998 Cairns
linocut, printed in black ink, from one block;
hand-coloured with stencils on white wove T.H.
Saunders paper
51.0 x 65.5 cm.
printed at the Tropical North Queensland
Institute of TAFE, Cairns
Gordon Darling Australasian Print Fund 2000
2000.288

Kathryn NORRIS
Language: Torres Strait Creole
born Australia 1977

Dogai figure-head
1996 Cairns
linocut, printed in black ink, from one block;
hand-coloured with watercolour on
textured cream wove paper
36.7 x 45.0 cm.
printed at the Tropical North Queensland
Institute of TAFE, Cairns
Gordon Darling Australasian Print Fund 2000
2000.331
© Kathryn Lucina Norris

Brian ROBINSON
Island group: Western Island
Language: Kala Lagaw Ya/Torres Strait Creole
born Australia 1974

Lurking Baidam
1999 Cairns
linocut, printed in black ink, from one block;
hand-coloured on paper
40.0 x 62.5 cm.
printed at the Tropical North Queensland
Institute of TAFE, Cairns
Collection: The artist

Ocean spirits
c.1996 Cairns
linocut, printed in brown ink, from one block
on cream wove paper
25.0 x 49.0 cm.
printed at the Tropical North Queensland
Institute of TAFE, Cairns
Collection: The artist

Nino SABATINO
Island group: Western Island
Language: Kala Lagaw Ya/Torres Strait Creole
born Australia 1975

Githali (Mud crab)
1997 Cairns
linocut, printed in colour, from one block
on cream wove paper
33.2 x 46.0 cm.
printed at the Tropical North Queensland
Institute of TAFE, Cairns
Gordon Darling Australasian Print Fund 2000
2000.289

Alick TIPOTI
Island Group: Western Island
Language: Kala Lagaw Ya
born Australia 1975

Aralpaia Ar Zenikula
1998 Canberra
linocut, printed in black ink, from one block
on paper
67.0 x 100.0 cm.
printed at the Canberra School of Art
Gordon Darling Australasian Print Fund 1999
1999.24

Kobupa Thoerapeise (Preparing for war)
1999 Cairns
linocut, printed in black ink, from one block
on paper
100.3 x 66.0 cm.
printed at the Tropical North Queensland
Institute of TAFE, Cairns
Private collection

Prints from Papua New Guinea

(Timothy) AKIS
born Papua New Guinea 1940 died Papua
New Guinea 1984

Masalai man (Spirit man)
1977 Port Moresby, Papua New Guinea
screenprint, printed in black ink, from one
stencil on paper
57.5 x 46.5 cm.
Gordon Darling Australasian Print Fund 1991
1991.488

Sikin i pulap long nil (Skin full of thorns)
1977 Port Moresby, Papua New Guinea
screenprint, printed in black ink, from one
stencil on paper
57.0 x 45.4 cm.
Gordon Darling Australasian Print Fund 1990
1990.27

Tupela man [Two men]
1977, reprinted 1985 Port Moresby, Papua
New Guinea
screenprint, printed in colour, from multiple
stencils on paper
57.5 x 46.0 cm.
Gordon Darling Australasian Print Fund 1991
1991.486

*Tupela marit kros long palai (A married couple
fighting, with a lizard)*
1977, reprinted 1985 Port Moresby, Papua
New Guinea
screenprint, printed in black ink, from one
stencil on paper
55.2 x 43.5 cm.
Gordon Darling Australasian Print Fund 1991
1991.489

Jakupa AKO
born Papua New Guinea 1942 died Papua
New Guinea 1999

Face
c.1980 Port Moresby, Papua New Guinea
screenprint, printed in colour, from multiple
stencils on paper
98.5 x 62.8 cm.
Gordon Darling Australasian Print Fund 1990
1990.34

Mathias KAUAGE
born Papua New Guinea 1944

Meme bilong mi (My goat)
1969 Port Moresby, Papua New Guinea
woodcut, printed in black ink, from one block
on white fibrous paper
37.0 x 28.5 cm.
Gordon Darling Australasian Print Fund 1990
1990.744

Plank bilong pait (Fighting shield)
1969 Port Moresby, Papua New Guinea
woodcut, printed in black ink, from one block
on thin white wove paper
44.0 x 27.0 cm.
Private collection

Tupela wokabaut (Two go for a walk)
1969 Port Moresby, Papua New Guinea
woodcut, printed in black ink, from one block
on white fibrous paper
29.5 x 36.7 cm.
Gordon Darling Australasian Print Fund 1990
1990.743

Untitled
1969 Port Moresby, Papua New Guinea
woodcut, printed in black ink, from one block
on thin white wove paper
38.0 x 30.0 cm.
Private collection

Helicopter
1974 Port Moresby, Papua New Guinea
screenprint, printed in colour, from multiple
stencils on grey wove paper
40.3 x 58.5 cm.
Crafts Board of the Australia Council Collection
1980
1982.2564

The first missionary
1977 Port Moresby, Papua New Guinea
screenprint, printed in colour, from four stencils
on thin white card
50.4 x 38.2 cm.
Gordon Darling Australasian Print Fund 1990
1990.30

O meri wantok mi seksek long you (Hey lady, I fancy you)
1977 Port Moresby, Papua New Guinea
screenprint, printed in colour, from multiple
stencils on paper
89.0 x 61.0 cm
Gift of Jim and Janet Fingleton 1991
1991.809

Masalai man (Spirit man)
1978 Port Moresby, Papua New Guinea
screenprint, printed in colour, from five stencils
on white wove paper
94.0 x 57.6 cm.
Private collection

Meri i wari (Worried woman)
1978 Port Moresby, Papua New Guinea
screenprint, printed in colour, from six stencils
on white wove paper
97.5 x 55.6 cm.
Private collection

David LASISI
born Papua New Guinea 1955

The confused one
1976 Port Moresby, Papua New Guinea
screenprint, printed in orange ink, from one
screen on white wove paper
51.4 x 40.9 cm.
Gordon Darling Australasian Print Fund 1990
1990.26

Saben
1976 Port Moresby, Papua New Guinea
screenprint, printed in blue ink, from one stencil
on white wove paper
48.0 x 48.2 cm.
Gordon Darling Australasian Print Fund 1991
1991.494

Samkuila
1976 Port Moresby, Papua New Guinea
screenprint, printed in blue ink, from one stencil
on paper
40.4 x 56.2 cm.
Roger Butler Fund 1990
1990.789

The shark
1976 Port Moresby, Papua New Guinea
screenprint, printed in mauve ink, from one
stencil on white wove paper
51.5 x 47.6 cm.
Gordon Darling Australasian Print Fund 1991
1991.495

The whore
1976 Port Moresby, Papua New Guinea
screenprint, printed in brown ink, from one
stencil on paper
49.5 x 39.2 cm.
Gordon Darling Australasian Print Fund 1991
1991.497

Martin MORUBUBUNA
born Trobriand Islands 1957

Untitled (Flying insect)
c.1976 Port Moresby, Papua New Guinea
screenprint, printed in black ink, from one
screen on thin shiny cream wove paper
22.8 x 43.4 cm.
Gift of Shirley Troy 1999
1999.58

Boi
c.1983 Port Moresby, Papua New Guinea
screenprint, printed in brown ink, from one
stencil on cream wove paper
53.0 x 28.5 cm.
Gordon Darling Australasian Print Fund 1990
1990.32

Cecil King WUNGI
born Papua New Guinea 1952 died Papua
New Guinea 1984

Untitled
c.1978 Port Moresby, Papua New Guinea
screenprint, printed in black ink, from
one stencil on cream wove paper
76.0 x 56.0 cm.
Gordon Darling Australasian Print Fund 1991
1991.491

Untitled
1980 Port Moresby, Papua New Guinea
screenprint, printed in madder ink, from one
stencil on thick cream wove paper
78.6 x 50.6 cm.
Gift of Kriss Jenner 2000
2000.246

Untitled
c.1981 Port Moresby, Papua New Guinea
screenprint, printed in black ink, from one
stencil on white wove paper
75.4 x 56.0 cm.
Gordon Darling Australasian Print Fund 1991
1991.492

Untitled
c.1981 Port Moresby, Papua New Guinea
screenprint, printed in black ink, from one
stencil on white wove paper
75.5 x 55.5 cm.
Gordon Darling Australasian Print Fund 1991
1991.493

Prints by Maori artists

John HOVELL
Maori people: *Ngapuhi, Ngati Whanaunga, Ngati Porou*
born Aotearoa New Zealand 1938

Manu tava: nesting forms
1987 Aotearoa New Zealand
lithograph, printed in colour, from multiple
stones on white wove paper
43.4 x 27.8 cm.
Gordon Darling Australasian Print Fund 1991
1991.690

E hoki te iwi ko tomatau Kainga
1988 Aotearoa New Zealand
lithograph, printed in colour, from multiple
stones on white wove paper
42.5 x 35.5 cm.
Gordon Darling Australasian Print Fund 1991
1991.689

Robyn KAHUKIWA
Maori people: *Ngati Porou*
born Australia 1941
Aotearoa New Zealand from 1960

My Tapu head
1990 Auckland, Aotearoa New Zealand
lithograph, printed in colour, from multiple
stones on white wove paper
30.0 x 50.0 cm.
printed in Muka Studio
1991.999

Tangata Whenua
1990 Auckland, Aotearoa New Zealand
lithograph, printed in colour, from multiple
stones on white wove paper
50.0 x 30.0 cm.
printed at Muka Studio
1991.998

Waitangi
from the folio *New Zealand 1990; lithographs
by 20 artists*
1990 Auckland, Aotearoa New Zealand
lithograph, printed in colour, from multiple
stones/plates on paper
71.2 x 50.0 cm.
printed at Muka Studio
Gift of the Government of New Zealand 1990
1990.1488.10

Paratene MATCHITT
Maori people: *Te Whanau a Apanui, Ngati
Porou, Whakatohea*
born Aotearoa New Zealand 1933

Taumatakahawai
from the folio *New Zealand 1990; lithographs
by 20 artists*
1990 Auckland, Aotearoa New Zealand
lithograph, printed in colour, from multiple
stones/plates on paper
69.6 x 50.4 cm.
printed at Muka Studio
Gift of the Government of New Zealand 1990
1990.1488.11

Prints by Pacific Islander artists

Fatu FEU'U
born Western Samoa 1946
Aotearoa New Zealand from 1966

Matau
1988 Auckland, Aotearoa New Zealand
lithograph, printed in colour, from multiple
stones on thick white wove paper
34.8 x 25.8 cm.
printed at Muka Studio
Gordon Darling Australasian Print Fund 1991
1991.691

Pale auro
1989 Auckland, Aotearoa New Zealand
from the folio *New Zealand 1990; lithographs
by 20 artists*
lithograph, printed in colour, from multiple
stones/plates on paper
51.0 x 70.2 cm.
printed at Muka Studio
Gift of the Government of New Zealand 1990
1990.1488.5

Manaia
1989 Christchurch, Aotearoa New Zealand
lithograph, printed in black ink, from one stone
on dark cream wove paper
52.8 x 44.8 cm.
printed by Marion Maguire at The Limeworks
Gordon Darling Australasian Print Fund 1996
1996.1001

Alo alo
1990 Christchurch, Aotearoa New Zealand
lithograph, printed in brown-black ink, from one
stone on thick cream wove paper
54.6 x 46.0 cm.
printed by Marion Maguire at The Limeworks
Gordon Darling Australasian Print Fund 1996
1996.1000

Tausala
1990 Christchurch, Aotearoa New Zealand
lithograph, printed in black ink, from one stone
on dark cream paper
55.6 x 45.6 cm.
printed by Marion Maguire at The Limeworks
Gordon Darling Australasian Print Fund 1996
1996.1002

Patrice KAIKILEKOFE
born New Caledonia 1972

Matala i Siale
1998
woodcut, printed in colour, from multiple blocks
on tapa cloth
32.0 x 32.0 cm.
Gordon Darling Australasian Print Fund 2000
2000.272

Puaka e Valu II
1998
woodcut, printed in colour, from multiple blocks
on tapa cloth
64.0 x 32.0 cm.
Gordon Darling Australasian Print Fund 2000
2000.273

Ta'ahine (Young girl)
2000 Nathan, Queensland
woodcut, printed in black ink, from one block
on white wove paper
130.0 x 30.8 cm.
printed by Jonathan Tse and Katarina Lytros at
Griffith Print Workshop
Gordon Darling Australasian Print Fund 2000
2000.269

Tama (Young man)
2000 Nathan, Queensland
woodcut, printed in black ink, from one block
on white wove paper
printed by Dian Darmansjah at Griffith Print
Workshop
Gordon Darling Australasian Print Fund 2000
2000.270

Joe LINDSAY (SALE)
born Solomon Islands 1964

Fonu / Turtle
1995 Solomon Islands
woodcut, printed in black ink, from one block
on white wove paper
19.0 x 15.4 cm.
Gordon Darling Australasian Print Fund 1997
1997.25

Se'ge / Crab
1995 Solomon Islands
woodcut, printed in black ink, from one block
on white wove paper
19.0 x 15.2 cm.
Gordon Darling Australasian Print Fund 1997
1997.26

Kokosu / Hermit crab
1995 Solomon Islands
woodcut, printed in black ink, from one block
on white wove paper
19.0 x 15.4 cm.
Gordon Darling Australasian Print Fund 1997
1997.27

John PULE
born Niue 1962
Aotearoa New Zealand from 1964

Pokia (Together)
1995 Christchurch, Aotearoa New Zealand
lithograph, printed in colour, from two plates
on thick cream wove Arches paper
65.6 x 52.8 cm.
printed by Marian Maguire at The Limeworks
Gordon Darling Australasian Print Fund 1996
1996.993

Pulenoa (Without consent)
1995 Christchurch, Aotearoa New Zealand
lithograph, printed in colour, from three plates
on thick cream wove Arches paper
64.6 x 53.0 cm.
printed by Marian Maguire at The Limeworks
Gordon Darling Australasian Print Fund 1996
1996.994

*Tokolonga e faoa in loto ne misi (Many
people in a dream)*
1995 Christchurch, Aotearoa New Zealand
lithograph, printed in colour, from three plates
on thick cream wove Arches paper
65.6 x 52.6 cm.
printed by Marian Maguire at The Limeworks
Gordon Darling Australasian Print Fund 1996
1996.995

Michel TUFFERY
born Aotearoa New Zealand 1966

Pili Siva
1988 Auckland, Aotearoa New Zealand
lithograph, printed in colour, from multiple
stones on white wove paper
63.4 x 46.0 cm.
printed at Muka Studio
Gordon Darling Australasian Print Fund 1990
1990.43
© Michel Tuffery, 1998

Pa'a e Tonga
1998 Cairns
woodcut, printed in colour, from two blocks on
cream wove paper
26.0 x 71.0 cm.
printed at the Tropical North Queensland
Institute of TAFE, Cairns
Gordon Darling Australasian Print Fund 2000
2000.276
© Michel Tuffery, 1998

Pa'a Lua
1998 Cairns
woodcut, printed in colour, from multiple
blocks on cream wove paper
27.0 x 70.0 cm.
printed at the Tropical North Queensland
Institute of TAFE, Cairns
Gordon Darling Australasian Print Fund 2000
2000.275
© Michel Tuffery, 1998

Christ Keke Fala Sa
1998 Cairns
woodcut, printed in colour, from multiple
blocks on cream wove paper
46.8 x 39.5 cm.
printed at the Tropical North Queensland
Institute of TAFE, Cairns
Gordon Darling Australasian Print Fund 2000
2000.277
© Michel Tuffery, 1998

The cross-cultural experience

Michel TUFFERY
born Aotearoa New Zealand 1966
VARIOUS ARTISTS
born Australia

A canoe of many passengers
1998 Cairns
woodcut, printed in colour, on canvas
84.0 x 208.0 cm.
printed at Tropical North Queensland Institute of
TAFE, Cairns
Banggu Minjaany Arts and Cultural Centre,
Tropical North Queensland Institute of TAFE,
Cairns
© Michel Tuffery, 1998

Robin WHITE
born Aotearoa New Zealand 1946
Kiribati 1982–1999, Aotearoa New Zealand
from 1999

Leba TOKI
born Fiji 1951

Tea, Milk, Sugar
2000 Masterton, Aotearoa New Zealand
stencil print, printed in colour with natural
pigments, through hand-cut plastic stencils on
three sheets of tapa cloth
198.5 x 226.0 cm. (sheet 1)
212.5 x 272.0 cm. (sheet 2)
202.5 x 250.0 cm. (sheet 3)
Gordon Darling Australasian Print Fund 2000
2000.453.A-C

Peter ADSETT
born Aotearoa New Zealand 1959
Australia from 1982

Yuan MOR'O OCAMPO
born Philippines

Djalu GURRUWIWI
Galpu people
born Australia 1940

Ardiyanto PRANATA
born Indonesia 1944

Dhopia YUNUPINGU
Gumatj people
born Australia

Gapu, tubig, air, water
1997 Darwin, Northern Territory
screenprint, printed in colour, from multiple
stencils on cream wove paper
89.0 x 69.6 cm.
printed by Basil Hall at Northern Editions
Gift of Nigel Lendon 1999
1999.126

Gapu, tubig, air, water II
1999 Darwin, Northern Territory
etching and aquatint, printed in black ink,
from one plate on five sheets of paper
94.4 x 49.0 cm. (each sheet)
printed by Basil Hall at Northern Editions
Gordon Darling Australasian Print Fund 1999
1999.145.A-E

FURTHER READING

Sean Mallon and Pandora Fulimalo Pereira, *Speaking in Colour, Conversations with Artists of Pacific Island Heritage*. Wellington: Museum of New Zealand Te Papa Tongarewa, 1997

Rangihiroa Panoho. Te Moemoea No Iotefa (The dream of Joseph). (exhibition catalogue) Wanganui: Sarjeant Gallery, 1991

Nigel Lendon, *On the Possibility of Collaboration*. (exhibition catalogue) Darwin: 1999

Maggie West (intro.) *Land Mark: Mirror Mark*. (exhibition catalogue) Darwin: Northern Territory University, 2000

Australia Art Monthly. July 1999, no.121 ('Pacific vision at home and abroad')

Susan Cochrane Simons and Hugh Stevenson (eds.), *Luk Luk Gen! Look Again! Contemporary Art from Papua New Guinea*. Townsville: Perc Tucker Regional Gallery, 1990

Melanie Eastburn, *Printmaking in Papua New Guinea*. Paper presented for the inaugural Gordon Darling Australasian Print Fellowship, 2000

Tom Mosby and Brian Robinson (eds), *Ilan Pasin: Torres Strait art*. Brisbane: Cairns Regional Gallery, 1999

Anna Eglitis (ed.), *Contemporary Aboriginal and Torres Strait Islander Art*. Rockhampton: Central Queensland University Press, 2000

Nicholas Thomas, *Oceanic Art*. London: Thames and Hudson, 1995